HORSE TRAILS HAVE NO ENDS

SASSpeedis

authorHOUSE®

AuthorHouse™
1663 Liberty Drive
Bloomington, IN 47403
www.authorhouse.com
Phone: 1-800-839-8640

First published by AuthorHouse 05/5/2011

ISBN: 978-1-4567-6824-9 (sc)
ISBN: 978-1-4567-6823-2 (hc)
ISBN: 978-1-4567-6822-5 (e)

I first of all would like to thank Sherman for giving me the inspiration to finish my writing that I have been working on since 1997, after my grandma left this world. Her leaving made me realize that there is nothing in this world I cannot do, or any place that I can't go. I have heard first about Sherman when his movie came out called "Smoke Signals". I loved that movie because it was so straight forward about the way us Natives live. Then, as the years went by after I came back from Bismarck, North Dakota where I attended United Tribes Technical College, I began to read Sherman's books after my part- time job because I felt I needed to find myself. I began to read his books since they were Native written. I started with "First Indian On The Moon", then, "The Absolutely True Diary of a Part- Time Indian". I really liked his books. The one that really got to me was his book that came out in 2009 called "Face". The cover just drew me in because it gave me that calm feeling from my frenzied emotions. As I began the book it seems like I flew through it until I got to the poem "Volcano". That poem really struck me because it was about when Mt. St. Helens erupted. I had a lot of things going on in my life at that time, and I think we were up in Bellingham, Washington at that time in my life. I have only in the past few months heard from people at the RV Park what it was like for them at that time. The second poem I would like to emphasize is the poem that really struck my heart and made me cry after I read it a few times called, "When Asked About an Indian Reservation, I Remember the Deer Story". The poem made past memories come back to the top of my mind, and it made me think I have to forgive our father for what he has done to us in the past. What he has done has made us into the people we are today; we just don't feel comfortable with him. Reading Sherman's work is so beautifully captivating as watching the most amazing sunrise with a dreadful storm blowing in from the West. I have told Sherman when I met him in Walla Walla, Washington at the Whitman College on April 15th 2010 that he is my hero, and always will be.

I first of all would like to thank Taman'wixla(JESUS) for letting me be reborn again in a way that completely changed my life forever for the better. I would like to thank my Ula'(grandma) for bringing me up on horseback, and for giving me those few inspirational words that I still have to this day. Our name comes from the horse family, and I would like to thank the family I have grown up in for bringing me up in such a rough-neck world to let me know that life is not easy at all, and to always expect the unexpected. I give thanks to a dear loved one Becky who was my counselor with the Yakama Indian Nation Behavior Health. Besides her being a good friend, she was able to tell me that I had Post Traumatic Stress Syndrome (PTSD) because I have witnessed a lot of traumatic things, plus also have been put through them. I would really like to give thanks to Chris and Mary, the leaders from Sacred Road Ministries because they helped out my family of three by moving their family over from Birmingham, Alabama to help our people, and for being there. I would like to give thanks to Leanne and Gerald for being there at the Yakama Nation RV Park for us to visit with, and for giving me those inspirational words to finish my book I have started back in 1997. I would like to give thanks to Mark also because we are both trying to publish a book, and I am in his sculpting class making a shark. I would like to thank the Yakama Indian Nation for me being brought up in practicing my language and culture, and traditions passed on to us from our elders; and being able to pass them teachings on to my children. I would like to thank the Yakama Nation Cultural Center Library for being there for me to best express myself by writing. I would most of all like to thank Merida K. for being there as a friend, supporter and teacher. For without her I would be like a lost filly going off a cliff into a huge pile of incomplete sentences, which I can't stand.

Contents

Chapter 1
RELIEF IS PAINFUL

At the time when I was young I had a real rough childhood in which there seemed to be no way to get away from; we stayed with our dad who always beat us when he got home from the bar, or just because he wanted to. There was my older brother and sister besides myself. He would always get mad at this woman and beat her up too. We didn't even know that she was our mom because when we saw her she was badly beaten. He would always beat us with a belt, or a strap (strip of leather) which hurt badly because it was struck in the same place over, and over making slashes that swelled up the body. The memory that is permanently branded into my brain is the time at night after he beat us children up, he would line us children up in the hallway and make us watch him beat up our mom.

The house that we stayed at was built right next to my grandma's house. She had a big piece of land where she had a lot of animals such as; cats, dogs, chickens, horses and ponies. I liked going over there to get away from the beatings for a day. There were times that we stayed the night at her house and also there were times when we would catch the bus to school from her house. There were times when our backs

would be bruised up from the beatings we had to take, or our faces would be swelled up from the knocks in the head we had to take. The school nurses would question us on how we got the bruises, and we would have to lie and say that we fell off a horse or something like that.

Our mom was getting beat up so badly that one day she just left; she couldn't take it no more. That left us children with our father. We would have to look forward to a beating every day. Until, he started to do something else to us children. We didn't know what to call it. He would make us go into a room down the hallway and take our clothes off. He would feel our bodies and do sick things. There wasn't anything we could do as we lied there in the dark listening to his heavy breathing. He said that if we tried to tell anyone he would beat us that night. He just beat the fear right into our minds. When we tried to tell our aunts or grandma next door what was happening, we didn't even know what to call what he was doing to us. The grown- ups would just shoo us away and laugh at us because who in their right mind would believe three little kids?. He would find out about us trying to tell and beat us that night. All we could say was that he was hurting us.

Chapter 2
WEW'NO SPEAKS

We would always go to our grandma's for comfort; to be with the animals. What I can remember clearly is our grandma sitting my brother, sister and me down and telling us she wanted all of us to graduate from high school and go to college. I did my best to live up to what she said but, my grandma and all the other grown- ups drank that stuff that our dad drank which makes them not act like themselves. Our cousins would stay at our grandma's house also; her house was very packed with grandchildren. We would have to watch where we were sitting because we had to watch out for falling bodies of our relatives. Alcohol had a real big say- so in my family; I don't remember any of my older relatives without it. I can even remember my father's parents always fighting.

Our grandma got custody, but we didn't know it. I can just remember staying at her house permanently. It scared us to have to think of going back to our dad's house. But, our dad would visit our grandma about every day. She would always go up to the mountains. I really like it when she would go and pick huckleberries because they taste so good! And, it also meant that the kids could run around. I even got old enough to where I started to remember where she would go; this one

place that she really likes to go was a place called Randle. We just knew that is was a far- off place to the north of Mt. Adams. She packed up the blue- truck she had that a canopy with lunch and baskets, and us grandchildren in the back as well. She had our dad drive her up to the mountains. The children had fun in the back because we had no grown- up to tell us what to do. When we reached the place finally our grandma went to go pick berries as the kids played. We didn't know what had happened to our dad. Nighttime was here already, and my grandma prepared a little meal over the bonfire. After the meal she was very tired from climbing them hills to pick the berries, and she went in the old army tent to go to sleep. We were not tired we just sat around the bonfire with our dad. Besides us three grandchildren there were our two- cousins. Our dad reaches into a cooler that he had beside him. He pulls out a drink. We all thought it was pop that he had. He takes a drink and passes it around the bonfire. We thought it was a treat that we were getting because our grandma would never let us drink pop. When the drink finally reached me, it had a sickening taste to it; I just took a sip. My dad tells me to keep passing it on. It wasn't very long before all the children were laughing at stupid things and kept on falling off the chopping blocks we were sitting on. It wasn't until many years later that I realized he got us drunk! We were just children, but that didn't matter to him.

Chapter 3
K'USIMA FEAR

I can even remember that all the grown- up people would go to this local bar called Lazy- R down the road a few miles. We would always wonder what they would do there. On this one hot day us kids were home at our dad's house; just my brother, sister and me. There was this big pile of used tires at the back of my grandma's pasture that we were too scared to go out to. Our dad tells us that we are going to go out there for a walk. We thought it was alright because we were with an older person. We walk down the road a bit where there was a side gate in the pasture. Our dad had to open the gate because it was held by barbed- wire. He opens it and shuts it behind us so the horses wouldn't get out. When we got in there, we decided to run to see who could get to the tires first. When we got there we were tired from running. We were going to swim in the third~ ditch that was way at the back of the pasture. But, when our dad finally reaches the tires he tells us to go to the back of the tires. When we get there he tells us to take our clothes off. We figured we had to do that so we wouldn't get our clothes wet. We were so far away from the road that hardly anyone went down. He had me lay on the ground. He tells my brother to get on top of me. We wondered why we had to do a thing like that because it felt so weird. I ask my brother," What are we doing?" He puts his hand over my mouth and tells me to hush up as we

heard the screaming of our older sister. Her body was hidden under our dad's big body. That memory is with me forever. There is no one in our family who would believe us because we were just children. We thought that it was just a way of life that we couldn't do anything about.

Chapter 4

ONE'S RAGE

I got really close to the animals because there is no older person who wants to hear what us younger children have to say. I would ride ponies anywhere that I could because I felt so free riding them. As time wore on, our rides got to be longer. We would ride our ponies over to the house where our cousins stayed in Brownstown. We got to ride in all the fields and dirt roads when we could. It was a privilege to be able to ride on the road because a kid had to be out of his mind to do that because cars and trucks on the roadway. I can even remember when we were real small that there was a rooster in the chicken-coup that didn't like any kid at all. We had to be wearing cutoffs because the day was hot. There were hens in the coup, so my grandma would send out the kids to get the eggs. Right when I got in the chicken- coup that mean rooster comes chasing after me! He begins to peck at my legs and I try to run out of there as fast as I could. As I got out of the coup I tripped over an old log that was laying across the trail for me to jump over, and I fell right on a wire sending it below my skin in my knee a scar that I still have today. The animal that I mainly loved was the horse because of the way that they hear you. They wouldn't tell me to shut up and be quiet. They listen with all their heart,

and I just had this fascination with them. She also bought us up as food gatherers also; that meant to get from the hills the roots, and the mountains the berries.

Chapter 5

SPIRITS FLY

In my middle school years when I was in 6th grade you could hardly keep my eyes away from the Southwest Art magazines. I always wanted to go to the Institute of American Indian Arts since 6th grade. My grandma was starting to trust my auntie and uncle who would take me traveling to rodeos with them. My auntie and uncle who were the parents of my cousins whose house we always rode to. I would go with them to rodeos in Washington such as Ellensburg, White Swan, Toppenish and Omak Stampede. In Oregon we would go to Pendleton Round-Up, Ty Valley, Arlington and Pi- Ume- Sha. My grandma even bought some new horses because the ponies were getting too small for us. She bought my brother a 16 hand high Thoroughbred- Sorrel. She also bought this 16 hand high black Thoroughbred named TJ. She gave that horse to me. He was so spirited. And, she also bought a 16 hand high Grulla horse who was ½ Quarter Horse, and ½ Thoroughbred; her favorite kind of horse because he is mouse- colored. He is so beautiful!

Less than a mile away from my grandmother's house there was this drain- ditch known to us children as the swimming hole. We liked to go swimming there because in the middle of the ditch the water was deep; over our

heads. To work the horse I was riding out, I would ride him bareback in the canal because it would work out the legs. I had my share of having different kinds of royalties such as for pow- wows and rodeos. In 1991 I ran for the title of Treaty Day Rodeo Queen. I sold a lot of tickets, but only got 2nd princess. So, I ran again the next year and got 1st princess. My aunt and uncle took me to rodeos with my horse to represent my title. I was having a great time. Ellensburg Rodeo was here, and two- weeks later was the Pendleton Round- Up. My auntie only decided to take two of my grandma's horses over there; TJ and the Grulla named Starbuck.

The Round- Up would be pretty good this year; except the nighttime because we would not all the time be able to go to the Happy Canyon. We would mostly go to the dance after the Happy Canyon. We would stay there for a bit, but then, where would we go? Where all the cowboys will go of course is the parking- lot. There would be a lot of my family that likes to go there. Ever since I've been going there that has been going on. I guess it was a way of the cowboys calming down after a days- work; but everyone went there. Even the young teenagers who were too young to go in the beer garden would be there. I'll tell you something, I never really liked that place at night.

Chapter 6

ROUND- UP SCAR

What it has been like for me to ride horses was a very dangerous thing for me to do because I went from riding ponies in the pony- race at the White Swan Treaty Day Rodeo; from ponies were that were a hard bunch to ride because they were "Shitters", as my family referred to them. They were not afraid to buck anyone off, to Thoroughbred horses created for sped. I remember going on rides long distances with my older cousin Gina because I was her favorite will pretty much say because she always had me rub her muscles on her back when she's been riding too long, or braid her hair. As I got older I started traveling to rodeos with my cousins parents. My grandma gave me a 16 hand- high thoroughbred who I would take to rodeos. I loved to ride horses anywhere that I could because I knew that it would give them a good workout, even in the winter time because going through snow would work out their legs. I would try to make it to the top of Ahtanum Ridge as much as I could because going uphill would make the horse sweat real foamy. When I was aboard the horses back, you can feel what kind of horse it was because of the way it acted. I liked to see the horse twitch its withers as I climbed on his back. As I would grab the reins to control the animal who

would dance in place before I got him ready for a race. His ears are forward to show you that he is alert. He keeps up dancing as the gate is opened to go inside the pen. You can feel that the horse is very nervous because he is around other racers. He is hard to keep from rearing up as he is guided around the oval- pen. The track director comes back to get us as we all have our horses ready. The horse is all excited because now he gets to run. His nerves are going crazy jumping sideways running us into another racer. He will even kick another horse he doesn't like. I am on his back skillfully moving my hands from my many years of experience taking a quick turn. He fires the gun off where the horses are spooked into a start that makes them jump off their hind-legs. As they plunge into running they are happy because they are set free! The horse has his ears back and has his head down low with only the reins to slightly touch his neck to guide him. You can hear the hoof- beats of the horses that are behind you trying to catch up to you as you near the turn. Sweat has gathered on your inner- thighs from how crazy your horse has been. Sweat is just pouring down his neck because he is so active from fighting being controlled. You don't hear the crowd hollering around because you are concentrating on the horse's stride. I love the feel of running on a horse because I feel so free, and let go of restraint. I love to feel the wind as it swoops through my hair making me look unsightly, but I don't care. After all of him running I know that I must take care of him and cool him down in a walk to calm him down. I know that my horse is tired as he starts to feed on his hay with me closing the gate to the corral wishing him a good night. That is my love of riding horses, and to let you know the pleasure I get.

We always arrived at the Round- Up the day before. When the first day of the Round- Up came about on September 16th, 1992 we were all excited. The rodeo starts at 1 o'clock. After the Natives went around the track for the Grand Entry, the

racers had to get their horses ready for the Squaw Race that was the 3rd event. After I took off the regalia from my horse's back, and me, I had to get him warmed up. That day was the day I decided to ride my grandma's horse Starbuck. I also chose to ride him bareback because that is the way I love to ride because I felt so close to him. As I was taking him to the warm- up pen I was thinking to myself, "I'm going to be pushed into drinking sooner or later. So, after the race I would go out to the beer garden and have a drink to help celebrate the first day of the Pendleton Round- Up." That was a big step for me because I have always been the nice one. I mean, I was 17, but kept pushing that ugly stuff away from me, always resisting. After this race, everyone will think that I am a cool person.

When I got to the pen, there were six- other women who were there aboard their steeds. We have to go around this big oval. We all had sunglasses on to protect our eyes from bugs and flying dirt. The horses knew what we were warming them up for and would rear up here or there making a cloud of high dust that all of our tensions would get mixed up in. The racers had hatred in their eyes you can feel below the sunglasses. We all had to wear, ribbon shirts to show that it was a Native race. I noticed something else too; I was the only one riding bareback and without a whip, and the only one without a helmet. I loved the horse I was riding, and I knew that he would take care of me. That is the only way that a person who was raised on horses can think of it.

We were all waiting for the Track Director to come back to the warm- up pen from the arena to get us. We heard the announcer tell the crowd that is was just about time for the Squaw Race. We all race down the aisle to get to that spot to get to the inside lane the quickest! I got there first. He lets us out onto the track! We're all racing there! I reach the inside lane first, and there wasn't going to be no way that I was going to let anyone push me out.

The crowd was already making their bets on who would come in first. We were all fighting with our horses to hold us steady! You had to see us. The horses just wanted to get us down the track the quickest. We're in the best line we could make just waiting for the Track Director to fire his gun off. We're waiting ... Just waiting...

"BOOM!!!" He sets us off! The horses are spooked into a jump start. Starbuck jumps into the lead as were heading towards the east in front of the southern bleachers. It is a race where the women have to run two- laps. The crowds was going crazy hollering and whooping around as I reach the eastern side of the track. I didn't care who was behind me at all, just that I was in the lead and wanted to keep it that way. The eastern side of the track was where most of the Natives sat. It seemed like we just whooped by them coming in front of the bucking chutes, and the announcer where they just cheered us on. We got done with that lap quickly heading towards the western crowd to the place where we started. I didn't have to worry about flying dirt in my face because I was in the lead. Getting in front of the southern crowd I could feel the heavy breathing of Starbuck every stride he took. I can just hear the hoof- beats of the women behind me. I didn't really pay too much attention to the roaring crowd, just what was around Starbuck and me. Getting around the eastern side of the track to where we started where we had two- turns left to take. I was all happy inside because I was in the lead. Getting in front of the bucking chutes, it seemed like everything went in slow- motion.

I could see a woman coming up behind me beneath my elbows. I looked forward again. This woman comes up right next to Starbuck's flanks and got their legs tangled up together. The last thing I saw was the ground coming at my face real fast then, it all turned black.

Chapter 7

COMING OUT OF COMA-TOSE

I didn't know what, or where in the world I was at? I know that I didn't feel any kind of pain at all. I didn't know that anything had happened to me because I had no memory. I was up in the clouds with a whole bunch of other people. They were all talking, but not making a sound. I saw this one person lying in a bed about 20 ft. away from me. When I got closer, I noticed it was me. I didn't feel any shock from seeing myself because it seemed normal. She was lying in a white bed all covered up to her shoulders. The room was white with a window that had long- white drapes hanging to the floor. She looked so peaceful without a care of the world she was in. I was with them people over- looking cities. I was in far-off states I have never been to before; like Vermont and Washington DC. I didn't know what I was doing in them places, looking around I would say.

There were these voices I heard that I couldn't make out? I could vaguely see who was talking to me. I finally got to remember what they were saying; they were telling me about this girl who got in a horse- wreck and had two-horses' roll on top of her. I thought of that ordeal she went through and said, " EEWW!! She must have gone through a lot of pain!" They kept telling me this stuff over and over

until my senses came back to me. It really hit me hard when I found out that girl they were talking about, was me! The first person who I remembered was the person who raised me as a child, my Ula'(grandma). I slowly got to remember the other people of my family as they came to see me. I felt as if this kind of stuff happens to people all over the world all the time; there was nothing special about what happened to me. I felt as though I would be able to go home soon. I was in a wheelchair. There was a young teenager boy who was standing on the other side of the room I didn't know? I asked my Ula' who that was. She tells me that is my brother.

Chapter 8

THAT VOICE

BOOM! It's like my head was struck real hard with a big rock. I remembered that we had a father. All the bad past memories came back to me clearer than rain on the top of huckleberries on a late summer morning. I began to weep telling my grandma that I wished I had died because I did not want to live with them memories. She tells me that I really did die, two- times. And, I just left it there.

A few more weeks went by, or so I thought. The doctors were trying to get me to walk; but it hurt! While I was wheeling myself in the hallway, I stopped by a room where the doctor was talking to my grandma. He says that I will never walk again. That's all I really remember. What I can remember doing that night after supper was staying up real late crying out of the hospital window. I didn't know who that was in the sky, only that there was someone there who would listen to me. I told that voice in the sky that I wanted to walk again, ride horses again and dance again. By the grace of the holy spirit something had happened inside of me within the next few days. I stood up the best that I could no matter how much it hurt me because I knew that it would help me get better. I went from a wheelchair, to a walker, to a cane. I was released from the hospital not too long after

I took my first steps. I was glad to finally be able to go home. I learned from my time at the hospital that I was in a horse- wreck in which I had two- horse's roll on top of me. The woman who came right next to my horse's flanks and tripped my horse is my cousin from that part of the country. Our horses' legs got tangled up and made Starbuck go down catapulting me over him making me land in the dirt with him rolling on top of me, followed by her horse. It caused a blood- clot to go in my brain, and the surgery done to remove it caused a whole right- side paralysis. The accident caused my right- side to not work very well for a great many years later.

As I was traveling towards home I got to see familiar places.
Certain signs that I used to ride horses' on. I got out of the hospital on December 4th, 1992. It is my favorite cousin's birthday. We went to her house so we could celebrate her birthday. My cousins' were all happy to see me and I got a lot of hugs.

After the party I was glad to finally be going home. Of course, there were a lot of my cousins who stayed at her house also; they slept in the living room. I got to sleep in a room by myself. I actually got the whole bed to myself. I was sleeping so peacefully until late at night I heard the front door bang open. Someone stomps down the hallway and comes to my door. That person kicks the door open so it hits the wall and stands above my bed. That person falls on top of me trying to get my pants undone as fast as he could. That person was my dad! There was no way in the world I was going to let him rape me; I was 17. I had to push his body off mine with the stronger side of my body so he'll be on the other side of the bed. I got up as fast as I could and went back to my grandma's room which was at the end of the hallway. She had suitcases and trunks in the hallway for me to go by. I stopped when

I almost reached her room because I remembered how no one would believe us when we were small. I knew that it was after closing time. I thought that at least my cousins would have woken up because they were asleep in the living room. I just hid behind one of the suitcases in the hallway, and he just staggers into the hallway, then he goes out the door. After he left I was afraid to go back into the room, so I went in the living room by my cousins and curled up in a ball the best I could right next to the fire that was almost out. I never spoke a word of what had happened because of the fear of what family would think, and say. I felt fear when I even looked at his house right next door to my grandma's.

Chapter 9

SCHOOL DAZE

It was Christmas break. I couldn't wait to get back to school.

But, when I went back to school, the other kids looked at me funny; they wouldn't even talk to me. They kept looking at the way I walked. My good friends I went to school with for many years now didn't want anything to do with me. I had only one good friend who knew what I went through. After a couple of days of trying to fit in with everyone else, the school counselor wanted to talk to me. I was wondering what for. When I get to her office she asks me to sit down. She begins to tell me that I can't go to school there no more because I spent three- months in the hospital. She said that I must go to Pace Alternative School to get my GED. I was almost fresh yet coming out of the coma I was in but, I knew what I wanted; I still remembered what my grandma had said to my brother, sister and me, "I want you all to graduate from high school and go to college." I told my counselor that I didn't want my GED, it's my high school diploma that I wanted. She tells me, "You must do this whole year over then." I say, "Then so be it."

I finished that school year out going to school a half a

day, and going to physical therapy. I didn't care about what the other students thought about me; I had to make what my grandma said a long time ago come true. I am the youngest child of us three- siblings, but I'm the only one who didn't drop out of high school. After I finished the school year out, I moved in with my auntie and uncle to travel to rodeos during the summer. It was a very hard summer for me because I couldn't run around with my cousins and be crazy. I threw away the cane after I got out of the hospital because I thought I could be like everyone else; but I couldn't because I had that bad limp on my right side. I got tired much earlier than everyone else. I didn't like going to rodeos anymore. There were a lot of times I wished I were not there because I felt so alone.

Chapter 10

COUGAR POWER

The next school year came about. I didn't have to start the year out at Wapato, where I've been going all my life; I went to White Swan High School. I thought that was pretty cool because mostly Natives go to school there. There was only one problem; everyone there stayed away from me there too. Sure, I had the best art teacher, my education was going alright. I had that fear of going home where I stayed in Brownstown because I might see my dad again. My uncle might invite him over to the house to have a drink for old- times sake or something. I couldn't talk to my family because I knew that fear they would never believe me. I had to talk to someone because I knew that I couldn't keep these feelings to myself. I have been going to see the school counselor at White Swan and told her the pain I was feeling. She could see that I was seriously falling apart with fear of going home, so she helped me get on a bus to go up to my step- mom's house up in Bellingham, Washington.

Whew! I felt such great relief to be out of that part of the country. Yes, I may have left my family, but they would never believe me. I just had to leave. My mom knows what we have been through because she had to live with him awhile. She has two- sons by him; our stepbrothers

from up north. Our younger brothers who are named after our dad, and his younger brother who is named after our uncle. My step- mom knew that I needed help, so she took me to the clinic on the Nooksack reservation to see a counselor named Jay. I forget his last name, but he really helped me. My auntie from down around the Valley found out where I was because I left without letting anyone in my family know where I was going. She didn't take me back home with her, she just left. I finished out my 11th year of high school up north, and went to summer school so I could graduate in 1995.

The family went to the Omak Stampede which always comes about the 2nd week of August. I saw a little bit of my family at the grounds, but I still didn't want to go home. I saw my good friends from Celilo, Oregon who were there mainly for the pow- wow. I went back to Celilo with the whip- woman who is also from our part of the country down on the Yakama rez'. She has family there also. Anyway, I started my 12th year at Wahtonka High School in the Dalles, Oregon. I made another new batch of friends. At every place I stayed at since I left my auntie's house in Brownstown, I always helped with the dishes or peeled potatoes. I spent about 1/2 a school year there before I had that longing to get back to my family because I had missed them.

Chapter 11
RIVERS END

I went back Christmas break. I got a lot of hugs, and them telling me they missed me. I don't know what I really missed; my family for the main thing. The only same thing that really didn't change is how bad the drinking got in my family, or it just got worse. Sure, I got to meet a lot of guys' that were at my auntie and uncle's house, but I had no fascination for any of them. That is until towards the end of the first night I spent at the house. My uncle introduced me to this guy from Eagle Butte, South Dakota his name is Kermit. My uncle had him at the house to help break horses. It was the old- house he was staying in. He seemed real nice and everything, but I was too busy getting carried away with my cousins.

After dinner was over I helped my auntie clean up the kitchen.

While I was rinsing them, this guy from South Dakota comes up by the dish cloth where I set the dishes to dry and asks for a spoon. When I turned around to give it to him our eyes locked up for a split- second. My cousin comes into the kitchen in her cool- kinda' walk and sees' the Eye- contact we are making. In the next few seconds she pushes me back into the hallway while I just had a big Ol' grin on my face.

The night went on with the guests leaving little by little. The night ended with us watching a movie called "Tombstone" in my aunt and uncle's room. My cousin's and I were in the room crowded around the bed in front of the TV. There were a few chairs in the room, but I sat on the floor by the bed. He sits in a chair on the other side of the bed. The lights were all off besides the light from the TV. The only times when me and Kermit really looked at each other was when the movie- screen showed a dark picture. I could feel his eyes looking at me as my heart was pounding just daring me to look back.

The movie seemed kind of long because we were all tired, but the movie ended with all of us teasing each other about people in the movie. I was already in my cousins' room, but I was going to go into the kitchen to get a midnight snack because I was just a bit hungry. Kermit was staying over at the old house, and that was where I thought he went. There is this long walk- way I have to go down before I get to the kitchen. As I was turning the corner, I ran into someone. I didn't know who it was at first, but a split- second later, it was him! I know it, Kermit. A second later not even our lips were glued together looking like they were part of a statue. The feelings of wanting to be with each other all night finally got to be free. We were kissing each other madly with our arms just going crazy over our bodies. It seemed like a few minutes passed before we really got a chance to look at each other in the face. He wasn't that cute, or very tall and handsome, but it's the inner- beauty that I was looking at. It was real dark because everyone was in bed, but there was a light outside that made the two of us see each other clearly. We took a minute to look at each other before we started into kissing again.

He tells me, "Come on, let's go over to the old- house."[H] I tell him, "I would love to go, then again it would kill me

because I met you under my auntie's roof, and I feel I need her permission to see you since you are uncle's ranch- hand.[H]

"That's OK, that's OK. I can wait a few days." He says.

The next morning before the sun rose I was pacing around on the kitchen floor nervous as can be on what she might say about me getting with Kermit. She comes in the house from feeding the chickens and takes off her coat. I take in a deep breath and had everything planned out on what I was going to say. I let the air out and say I would like to talk to her. Her eyes lock up with mine to let me know she kind of knew what I wanted to talk to her about. She says, "OK, lets sit down at the table."

I tell her it is one of the men who work for them that I'm pertaining too. I wanted to know if Kermit and me can get together for a few days, and see where we take it from there.

She tells me, "Sure, I can't tell you who, and who not to be with now that you are of age."

"Yippee!" My whole insides were jumping up and down doing somersaults! I couldn't wait to tell him. He was out with my uncle fixing fences. They were gone most of the day, so I had to wait for them to get back.

My uncle and Kermit came in the house about mealtime. We ate a good meal of good country cooking. After dinner was over, I helped clean up the dishes. Kermit was getting ready to go back over to the old house. I told him to wait for me over there because I have something to tell him.

As I was helping clean up my cousin was teasing me because she knew where I was heading. I didn't really pay attention to what my family was doing because I had exciting chills running throughout my body; starting in my head, then working its way down to my feet.

As I step outside onto the porch before I head over to the old house, I look up and see a clear dark- blue sky with millions of stars looking like a leopard appaloosa tamed down to a sweet gentleness. I notice the ground on each step I took over to the old house because it is a rickety trail. It is a ranch with a lot of animals who were mostly sleeping in the December night. When I get to the door in the cold night, I make a few knocks. He opens the door with a smile upon his face that where his dimples showed upon the moonlight. I tell him, "She said it would be alright if we saw each other. I just thought I should ask her first."

He keeps on smiling and tells me, "Come on in, come on in and be my guest. For whatever else, let's say not."

He takes me back to my cousin's old room where the light was coming from. When I get there, there are some clothes laying on the chair and floor. He picks up them clothes real fast so I can sit on the chair, and throws them by the closet door. The room was cold, but he asked me if I want to sit down in the chair? I was very tired, but the anticipation of the moment kept me awake. I also kept wondering what he would ask me to do. As we were trying to warm up in the room, he asks me if I would go out with him. At the time he asked me I heard the whinny of a horse in the nearby corral.

I was amazed! No one has ever asked me that before. I mean, most guys just want to get down to business; you know what I mean. I grabbed his hand and said that I would like too, but I still had education on my

mind. I had a half- a- year to complete my 12th year; my graduation was coming up in a few months and I had a lot of planning to be doing. I told him that I would have to ask my auntie if she will take me to Celilo to get the rest of my belongings.

We began to talk about what makes us happy, and went to bed about an hour later. He had a sleeping bag with a couple of blankets inside for us to cuddle up in the cold December night. We were so close to each other where our breathing just heated up the whole sleeping bag. After we made love, we just fell asleep holding each other as the cooing of the night birds put us to sleep. As we woke up the next morning we heard my auntie feeding the livestock; she does that before the sun comes out. A few hours went by before I sprung the news that I was going out with Kermit. I told her that I would like her to take me to Celilo to get the rest of my stuff. Anyway, the next thing that I knew, my cousin and her was taking me over to Celilo. I thought that it would be hard to leave the Whip- woman's house when I told her that I wanted to go home, but she said that it would be alright for me to go home. I will have to admit, Celilo had too much alcohol in the village at that time. I didn't really know too- well the drunks from Celilo. I missed the alcoholics from back home, even though I stayed away from the drinking. I thought it was my uncle I missed, and all the wild parties that he would throw. Or maybe, I think the main reason was that I knew that Kermit drank, and I knew that he would be at my uncle's parties.

I moved out of my uncle's house in Brownstown when the Winter Break was just about over, and moved in with my other auntie who stayed nearer to where I went to school; in Wapato. That was the school where I went all my life before I started the quest to get away from my family.

I moved out of my auntie's house in Brownstown and moved in with my other auntie who stayed nearer to Wapato. That auntie stayed there with her husband, and their two- children.

He also moved out of my uncle's house to move with his brother who was going out with my other auntie who stayed nearer to Wapato as well. I would sometimes ride the bus home to the house where he stayed to be with him awhile. But, my graduation was going to be here in no time, and I had so much to be doing that kept us apart from each other.

My graduation night was finally here, I was so excited. Kermit was at my graduation that seemed to make the night perfect because he was at one of the most important days of my life. There were about 75 of us students graduating. It was a long procession, but it eased my mind to see him in the bleachers in his faded blue jeans and plaid shirt. I didn't really get to see him until after the procession at the banquet in the courtyard of the school.

I don't really remember my graduation. 1 can just mainly remember I was with Kermit, and that I had made part of what my grandma wanted us to do when we were small; to graduate from high school. I just had to get to college, but I had the summer to get through.

Treaty Day weekend was finally here! I had the whole weekend to spend with Kermit, I thought. I had the best time that 1 could at the rodeo. I couldn't have a really good time because I had to watch out each step that 1 took for the bad limp I had on my right-leg. I tried to go to my uncle's big beer party that he had, but I always felt out of place. I didn't see Kermit until the day after the rodeo. I felt so bad.

He was outside of my uncle's house with his brother and sisters' in an old car. His brother goes in the house so he can talk to my uncle as Kermit and I go out back of the house. He tells me, "We're heading back to Eagle Butte, South Dakota. I want to know if you'll come along."

We were both holding each other as tears just started rolling down my face. 1 say, "I don't think I'm ready to go yet."

He began to cry also with our tears hitting the ground like solid- bricks. We were wondering how we could ever be apart because we have grown so attached to each other.

His brother comes out of the house as Kermit and I come to the front of the house holding onto each other. His brother says that they will be waiting in the car for him. We didn't want to let go of each other, but we just barely parted. The last time we touched was at our finger-tips. When he gets to the car, he turns around and looks at me an gives me one final wave before he gets in to the car.

I waved back to him as the car went down the long driveway. I kept on waving until the car was out of sight. He seemed like a river flowing away from my heart. I never saw him after he left. I tried to come back into contact with him, but I will guess he don't want to deal with the past. He was the first real love of my life.

Chapter 12
GET A LIFE QUICKLY

It took me awhile to get over him, or did I really? I don't think I ever will. Well, I still had to continue on with my life, even though it seemed like the best part of my life were over. I moved in with my best friends who stayed up in Yakima. We would always go to a pow-wow, of gathering down in the Valley. While we were at a pow-wow in White Swan, I fell in love with this guy who was part Native, I guess. We got an apartment of our own, it was good for awhile. It came down to that point where I had to leave him because he began to beat me. He just came right out and said he was getting tired of me. I went through a few weeks of heartbreak, thinking I was supposed to have a boyfriend. I got with someone else from down by the river. It's not like I really got to know him. It was mostly his father I got close to. Sure, he was another boyfriend who mainly wanted from me, what is between my legs. What did I do? That Fall after graduation I went college at Yakima Valley Community College, and tried to major in something to do with the art field. I have been drawing ever since I could hold a pencil because of the way I was raised. I had to have some way to express my feelings. The college didn't have an art program at the time, so they put me as a English major. It was not as exciting as

I thought it would be. I got a new bag, books to study by, and some new clothes. But, I just was not happy. I couldn't figure out why? While I was at school, I went to the Higher Education and filled out an application to go down to The Institute of American Indian Arts in Sante Fe, New Mexico. Now me, I thought I could never get all the way down there. The college up in Yakima, I knew it too well. I wanted to go somewhere that I have never been to before.

Chapter 13
WRONG WAY RIGHT

As I was filling out papers to go to that college, I had no help from my family at all. I kept on getting exciting chills in my body that would start in my tummy, and end in my head. My Higher Ed counselor kept telling me that I would really get down there. It had to be run through my head a few times that I would really go down there to the college I wanted to go to ever since 6th grade. Me, I have no trust at all for planes because they could crash. I really liked the Greyhound Bus. It took about a day and a half to get there. I traveled from Washington, through Oregon, California, Arizona then New Mexico. I really liked that journey. I went to that college the year of 1996-97. I wanted to major in painting, like I have seen in the beautiful Southwest Art Magazine. But, they have been looking at my grades; the degree I should really be in was Creative Writing. My best grades in high school were in English. I felt kind of cut short, but I went to that class anyway. I had the best Creative Arts instructor who helped me open up my mind. I wouldn 't have known I was a good at poetry. What I was real good at was telling my real-life experiences. I thought it was not a good writing when what I wrote made me cry. I have noticed that about a lot of my writings that they really tell the truth on what happened in my life. There

was this woman in my class who would always come and talk to me; I learned that her name is Mary. There were people at that college from all over the world such as, Alaska, Japan, Oklahoma, Montana, New York, plus other far off states. Well, my friend Mary was from Arapaho, Wyoming. I even met a real cool guy from Gallup, New Mexico who was a jeweler. There was one guy who was from my reservation. I didn't really get over my father trying to rape me the night I got out of the hospital. The memory of him doing that followed me down to Sante Fe. I was having a good time with the people I met down there and everything, but I was dying inside myself. I would always go and talk with my friend Mary; I let her know how I was raised. She couldn't really do nothing but listen; that's all I needed. I never had anyone who would listen to us when we were small because I was raised in a real hard-neck family. A family who didn't let me express myself. I didn't think it would be possible, but I drove myself to that point of committing suicide. If my dad wouldn't get out of this world, then I will. I wanted to get away from his memory for good. I was feeling so much self-pity for myself. When it seemed like nothing else could be done, my friend took me to her sister's house also in Sante Fe. I can't remember what kind of religion she was because I was too torn-up to even pay attention. All I know is that she had a bible. She prayed, and prayed for me. I didn't really think it would do any good because I was raised in a different sort of religion. A miracle happened! My life completely turned around. It was a way of reminding me that there is always someone who I can talk to who will listen. It was God who saved my life. I felt like a great weight had been lifted off my shoulders. In the next few days, I knew that writing was the best way for me to express myself. I wrote the best story about how I was raised the wrong way, and what has all happened to me. The best thing I could do was give my thanks to my friend Mary for taking me to her sister who helped me see the light.

Chapter 14
TRAGIC FIRE

Writing that story really helped me. I was down at college 1996-97. I did one school year, I had the summer off. I moved in with my friend Mary who had an apartment in the town of Sante Fe. It was her and her three kids that stayed with her. I thought I'd stay with her awhile before I traveled back up North. She was like the sister I never had. I already paid down on bus ticket to get me back up North. There were a few weeks before I had to leave. I had one more weekend to spend down in Sante Fe. There was a rodeo down there called Rodeo De Sante Fe. I was supposed to catch the bus that Monday after. I wanted to go back up and see my grandma, she was dying inside because she had diabetes. Her lower right-leg was removed because of that disease. But, I wanted to go and see her because I have done the things she wanted of my brother, sister and I when we were small; to graduate from high school, and go to college. I was all impatient to get back up North so I could see her! I went to Rodeo De Sante Fe, it was alright I guess. There wasn't anyone down there I knew; they were mostly Hispanic. I acted like I was having a good time, I guess. I was too anxious to get home. It was fun to see the horses win and buck off their riders. I had a good time the first

night. I had to wait out in the parking lot late at night, but I found her. I told her about how the night went as we drove back to her house. Then, she got a real serious look on her face when we were about six-miles from her house. She pulls over to the side of the road to tell me that my auntie called me from up North; she wanted me to call her, she said it was an emergency. I was all scared on what could've happened! I kind of knew what might've happened, but I kept pushing that to the back of my mind. I asked my friend Mary to stop at the nearest All-Sups so I could buy a phone-card. I got the card and we headed back to her place. Before we got out of the car she tells me, "Your grandma died." I didn't want to believe it! It can't be true! Not the person who I mainly wanted to see. I fell into Mary's arms bawling like a baby! She held me in comfort to let me know she'll be there for me. I didn't want to believe it was true, but why would my friend Mary lie to me about something like that? What have I done to make her mad? After awhile of crying, I went in the house to call my auntie. I nervously unwrapped the phone card out of the plastic cover it had and dialed the numbers. She answered the phone, and I asked her what had happened, all though I knew what her answer would be already. She tells me that grandma has died. I fell apart again. I didn't want to believe it. She tells me that they have wired me down a plane ticket to leave from Sante Fe the next morning at 6 o'clock. That was only about seven hours away, I had to get packed. It was late at night, but I stayed up packing. I was crying all night from hearing the news. My friend takes me to the airport. I give my friend a hug and thanked her for breaking the news to me, even though it must have been hard for her. I got on my first plane ride; it was a little plane to get me to Denver, Colorado. I stayed awake on that plane, I got through it anyway. I had to get on a bigger plane in Denver. It had a lot of people on it too. I had a window seat. I don't even remember the

take-off because I fell asleep right away from staying up all night crying. When I woke up, I was seriously scared to death because I woke up in the clouds! I thought I was dead again because when I was in that coma, I was up in the clouds with other people! I held onto the seat real hard because I was so scared. It took me a bit to come back to myself; when we were on the ground. It was that time where I really took it in that I have to stop thinking of myself; I must be strong for her sons and daughters.

When I got to the airport in Yakima, my grandpa and auntie were waiting for me in the terminal. They took me out for breakfast. But, they acted as though nothing had happened? They were not all torn-apart like I thought they would be. They took me back to where her body was lying, and we did services for 2-days. We had a crying ceremony. I went back to my auntie's house in Brownstown. Everyone was quiet, like nothing in the world has happened. That's when I started to write out my feelings because no one in my family would listen to me. The Non-Fiction story is called, "Tragic Fire." You just heard the whole story. It started with being down in Sante Fe with my friend, and it just ended right when I named the title of this story.

Chapter 15

HART BRAKE ROAD

I didn't realize it at that time in my life, but doing certain writings really helped me get through the difficult times in my life.

Everyone in my family seemed to be turned off from feeling any "kind of emotion". But, I had these feelings that kept turning up my stomach! I couldn't cry around my family. Either they wouldn't listen, or tell me to do my crying somewhere else. Sure, I could always turn to the animals for emotional- support, but I needed to do something else. So, I just wrote. There was this one day a few days after my grandma's burial when my cousin was sitting by the kitchen window talking to a person who was standing by the window. That person was my old childhood- sweetheart. I was sitting on the couch in the living room staring at nothing, feeling depressed. I kept on asking myself; "What happens now? What do I do?". Then, that guy walks in the door, and in the living room and calls my name, and sits down by me. He tells me he's out at the house helping my uncle to break horses. We get to talking, and talking. I tell some of the pain I was feeling. He just holds me, and he gets me to go out with him because all the pain I was feeling, it couldn't be held up by the strength of my family.

After I got with him, I decided to get my neuro-plant taken out because I believed I have finally found my one true love. Only a few days after, I got pregnant with a daughter. But, oh gees, right after I got pregnant, he had to go out and celebrate. He took me to every bar in the Valley imaginable.

I still had education on my mind. That Spring semester, I went to college at Heritage College. But, after my daughter was born, he kept on celebrating. She was born the month after mine on July 8th. He would go on drinking binge, after drinking binge thinking I thought that was all right. I would pack up as much as I could in her stroller, and try to get as far as I could because his mom's house was way out in the country. I would get about a mile or so before he would come and get me. To tell you the truth, I was kind of mad at his mom because she would always buy him as much beer as she could, or take him to any bar he wanted. He even got me to believe that the woman he bought home was a girl he said was homeless. While I was sleeping with him in bed, he waited until I was asleep and then went to go have sex with her. A few days later I went to the clinic and found out I had a disease passed on from having sex. I got treated, but there was no way he would go do something like that. He would always leave me home with our daughter.

Me? I knew I didn't have to be treated that way. While he was out at a bar with his mom, his niece let me use her phone so I could call an auntie that I trusted very much to help me get out of the situation I was in. She came in no time and got my daughter, and me out of the hell-hole we were in. My daughter's father never tried to come out to my auntie's house because he knew that he was not wanted around there.

I was free to raise my daughter on my own. I right

away got her last name changed to mine because her father did not deserve to pass on his name because he never came to see her, and he never helped with child-support. Her name was changed to Ranetta Leanne, even later her name was changed to Ranetta Esther because I think she looks just like my grandma. I was so happy that was done. It was finally time to start living my life again.

Chapter 16

TRY TO SEW THE HEART

Anyway, a few years went by, or so before I got with someone else not long after I moved back from Pendleton, Oregon where the other side of my family is from. These people were from my mother's side of the family. I stayed with my late mom's sister. It wasn't family I knew too well because we were forced to grow up on the Yakama 'rez. It was heartbreaking when we left. It hurt my auntie so much, that she cried when we left. I went down to Rock Creek LongHouse with my auntie that I have been staying with ever since we came back from Pendleton. I met this guy from over by the river also. He seemed like a very traditional man to me because he told me that he went to that longhouse over there. He had long hair. That is what I really love about a guy, is that he should have long hair and not be embarrassed about it. He of course had daughters of his own from a previous relationship. I spent most of the day with him. The next weekend I went back to see him. I moved my daughter and me with him in Goldendale, Washington.

That was where the real hard stuff started. He sent his kids off to school; braiding their hair and giving them something to eat. He tried doing that for awhile before his

ex-woman came to get the kids and moved to Seattle, Washington. I learned that the kids were not really his, he just claimed them because the real father would not. What really made that hard was after the children left he began beating me. I thought that was just a normal thing because all the women in my family have been beaten. I felt there was nothing I could do. I just took the best care of my daughter that I could. He tried so hard to make a life happen within my body, but when I got mad at him for beating me up I would just go to a health care facility and get on birth control. He would get mad at me for doing that, but it was just so I could keep my little family safe. The beatings continued even when we moved over with his dad in White Swan. His house was way out near Ft. Simcoe. My daughter and I were staying at the Oxbo Motel in Toppenish. He would always invite his sisters' to go drinking with him. He would have me take them places because I was the only one who had a license and a van. One night I can remember when the people of his family had a drinking party out at his dad's house. His sisters' had my van haul alcohol out to that party. I tried asking my boyfriend if I could have the keys to the van so we can go home. He just laughs at me in his drunken stage and tells me that his sister has the keys. I ask her for the keys and she just laughs holding a bottle of ugly stuff. I reached for inside her pocket to get the keys, but someone had grabbed me by the back of my hair and jerked me back to make me land on the floor. It was him, my boyfriend. He gets mad at me for getting mad at his sister. He had his head real close to me spitting at me and yelling at me drunker than piss. He beats me up real bad again throwing me around the room. He throws me back between the door into the hallway where I fall on my daughter pushing her back against a desk. She all of a sudden begins to scream! I couldn't see what was wrong with her at the time because my beatings went on.

When it was nearing nightfall his sister would not give me the keys to the van. I was going to take my daughter and start walking. His other sister would not let me take my daughter because it was getting night, and it was cold. I really tried to take her, but his sisters' would not let me. I cried hard as I began to walk down the road. I walked about a mile before I caught the ride of a very nice man to the Sub-Station. I had the Station call the Tribal Police because my daughter was still out at the house of his father's. The Sub-Station checked me over to make sure that nothing was wrong with me, but I didn't care about the health of myself because I was mainly worried about my daughter. The police took me out to that house. My boyfriend and his sisters' had left the house in his dad's car. The police went inside the house and found my daughter with my boyfriend's father. Her head was still bleeding in the back. The police right away took us to the Sub-Station to get treated. She only had to get one-stitch in the back of her head, but it will have to take many stitches to try to sew up my heart but I don't think that is possible because it is too deeply embedded.

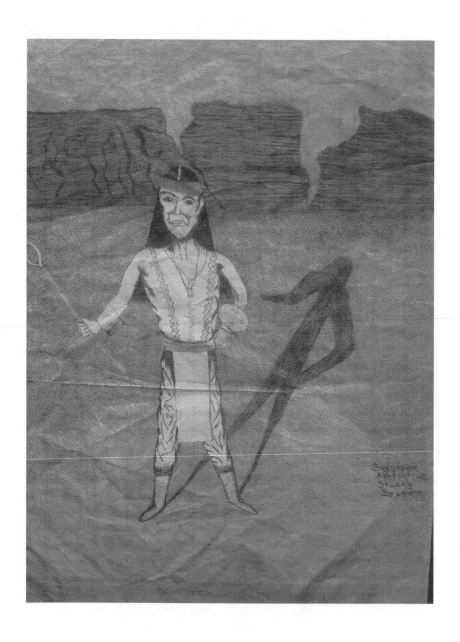

Chapter 17

JUST TRY IT!

I made the mistake of going back to him because I felt there was no one out there in the world that would look at me with my disability. It felt like he was the only man out there who would understand me. The beating meant nothing. I could take any kind of beatings. When he was gone from the Motel for about a couple of weeks on his drinking binge, his dad stops by the room where my daughter and me where. I could see it in his eyes that he was kind of shot because they were hanging down. He asks me where his son is at. I tell him that I don't know because he has been gone for awhile. He tells me that he has to lie down for a bit because he is tired. My daughter was sleeping on one bed in the room, and that is where I moved in the two-bed room. I had my nightgown on that before I answered the door I put on a long-sleeve western shirt to go over. When I let him lay on the bed I move over to the other bed where I can watch Three's company. After awhile his father gets up from the bed and comes over by me. He reaches onto my shoulder and tries to pull down the western shirt. I had to be faithful to his son. I stood up and cocked my head in a slanted position just daring him to make another move. I had a serious look on my face as he pulls away real fast. He tells

me, "Oh, I guess I better go because I am not feeling tired no more."

Man, I was in shock. His father was trying to sleep with me. There was no way in the world I was going to let that happen to me all over again. When my boyfriend came back the next day I told him of what had happened. He of course thought that I was lying about his father. I told my boyfriend to ask his father. So, he asks his father who completely denies it. My boyfriend of course takes the word of his father's. He is supposed to be this great leader. I felt hurt because my own boyfriend would not even believe me. But, a situation like that has happened to me all my life. I thought that I just had to stuff it under the pillow and tell no one at all because I was with his side of the family.

Chapter 18

VALLEY'S END

After awhile of me taking beatings to where they happened every day, I got pregnant. My boyfriend was so happy that he went right out and celebrated with his sisters. At that time we were staying in Goldendale. My daughter was three when I got pregnant. We had this woman who was a friend of my boyfriend. He would always go to her house to do drugs with her. I thought that was alright, just as long as we stayed away from it. I even knew that he had a sexual thing going on with her. I guess that was to show that he was getting too tired of me.

When I got with him, I realized that he was not going to that Rock Creek Longhouse anymore. If he did, it was only for ceremonial purposes. He was not as traditional as I thought he was. Anyway, we ended up moving back to the Valley. I had a son by him. His father decided to give him the name since he was a boy. He named him Joshua. The only thing I really liked about the name was that he was named after Joshua in the Bible. I never "really" knew GOD, only that he was truly blessed. What I thought was that I had to worship in the religion I was brought up in; the Waashut religion. He was born October 23rd 2002. I always talked to that spirit in the sky to help me get rid

of some of the pain I was feeling. Our son got his India
name when he was three months old; it is Scwe' le lut.

I have two- kids now. I love them more than anythin
in this world! We were staying back in an apartment i
Goldendale. He had his younger sister and her boyfrien
at the house. We were all playing a game. Our son begir
to cry. My boyfriend acts like he's the one who takes car
of him and goes to him. He gets mad at me becaus
there was a pile of dishes I the kitchen and yells at m
to do them. I get up all mad and stomp to the sink. H
comes over to me after he puts down Joshua and strike
me across the face. I didn't really feel his blow on my face
I felt anger. I threw my glasses real hard against the wa
and face him. I could have really hit him, but I kept m
hands to myself because I knew that I was outnumberec
I let him beat me up some more before he told me to ge
the hell out of his house. Gees, it was my Social Securit
that paid for that apartment. He forced me into the roor
with my daughter to pack our belongings. Our son had t
stay in the living room with them. I packed all our stuff. M
boyfriend comes in the room and sees that I also packe
Joshua's clothes. He pulls them out of our bags and throw
them on the floor before he comes over to me and pick
me up and throws me across the room. He comes over t
beat me up some more. I felt there was no where I coul
go because his sister comes in the room. I felt so sa
that my daughter had to witness all that happened. H
threw me again against the wall where I landed by m
daughter. His sister tries to take her in the other room, bu
she grabs onto my arm as tight as she could crying. Ther
was no way in the world that his sister could get her off m
arm. My boyfriend just yells at me to hurry up and get ou
of there. I get all of our belongings out of the house an
loaded them into the van. I had a Ford Aero star. While
was packing stuff out I put my daughter right in the fror
seat. I try to reach for my son's sitter he was in, but h

sister stands right above it just glaring at me daring me to make another move. I cried as I got into the van because I could not take him. At first I thought there was nothing I could do. We felt so alone without my little one. I got so attached to him because I only carried him inside my tummy for nine-months. But, after awhile I remembered that he has a record with the police. I went right away to the Goldendale Police. I had my boyfriend turned in to the police for Domestic Violence, and kidnapping. I gave them the address where they were at. It seemed like they picked him up right away. My daughter and I rode in the police car to go to that address to pick up our son. His sister who was there before answered the door as the police officer asked where my son was. She said right away that he was at their other sister's house across town. He has a big family in Goldendale. I gave the officer directions to her house. It was late at night as the officer knocked on her door. This sister is older than my boyfriend. I saw his sitter in the living room. His older sister would not let him go with me. She told the officer that I had an anger management problem. I said in a stern voice that I'm going to counseling for that. I don't think that I had a problem with that, my boyfriend said that I was crazy, and I got to believing him. The police officer told my boyfriend's sister that if she would not give me my son, that she can go and sit right next to him in the cell. She gives him up right away. I thank the officer and he takes us back to my van. The three of us just head back to the Valley and I right away the next day get a restraining order against him.

Chapter 19

DREAM SCAPE

I had my kids and I stay at my auntie's house in White Swan. I still had education on my mind. I went down to see the Higher Education officer down in Toppenish. He told me to go to another department because he couldn't help me go to college where I wanted to go. So, I went next door. I filled out papers to go to the United Tribes Technical College in Bismarck, North Dakota. I figured, I already went down South, I might as well try east. I told the officer that I was working with the situation I was in, and how much I wanted to get away from this reservation with my children. They could see that I still had that desire to learn, and that United Tribes has family housing and daycare right on campus. The department I have been working with got the Yakama Tribe to pay my whole tuition. They just wouldn't pay for housing. I had to wait for about a month to go there.

I was still worried about the safety of my son because he has family that stays in the Valley also. It was a hot summer for over here in these parts I guess. I tried to stay in the house the best I could. My daughter would always ask to go to the basketball courts with her friend. I'd say that was alright. She would always go in the afternoon. One day she asked me to go with her. When I got there

it looked like there was a small gathering. I love to meet new people, and it looked like there were p'ushtins(white man) over there. I wasn't scared of them, so I walked over there. There was a tall white man over there who I talked to first. He said that they were a family who came over from Alabama. He introduced me to his wife and children. His name is Chris, and his wife's name is Mary. They were from the Sacred Road Ministries. I met them when my son was still in a stroller. Chris obviously has been to this reservation before and he decided to move his family over to help the Yakama reservation.

It has been so great ever since I met them. My daughter was obviously attached to them because she always liked playing with their children. They did something else too; after playing they would get everyone in a group to talk about the Bible. I thought that was kind of strange because that religion was not really practiced that much around here; it is mostly longhouse. I got to thinking again that hardly anyone around here goes to longhouse every Sunday in White Swan. If they did it was mostly for ceremonial purposes. I tried my best to go every Sunday that I could because my grandma has bought me up in that way. We try to go to any longhouse that we can. I want to bring my children up in the same religion I was bought up in. Not raising them the same way I was; what I went through. What I have been told as a young person is that the Bible has a whole bunch of lies in it. It got me scared to read the Bible. But, my good friends Chris and Mary walked me into the Christian way. They did not throw it at me like it has been done in the past. Anyway, I believe in Jesus Christ because he has saved my life so many times. I feel that I wouldn't have been here without him. It has taken me awhile to really say I really believed in him because I thought that a person had to follow the religion that they were bought up in. But, I have also heard that it is good to try other religions. Being in the

Christian religion didn't scare me as much as I thought it would. I'm thankful that I met Chris and Mary and their family.

Chapter 20

HIS CHASE

I met them not long before my children and I moved to North Dakota. I had my cousin help me to drive over there. We had everything packed in the van. I felt such great relief to be getting off the Yakama rez'. It was easy to get through Washington and the top of Idaho, but I thought that we would never make it through Montana. It was a beautiful trip though. I have been on the same roadway before when I was back in high school when we went to Minnesota for a UNITY conference. The long pass in North Dakota was getting from Glendive to Bismarck. I didn't think we would really get there because you know of that anticipation a person feels about going to the 2nd best Indian art college in the United States. Well, I know it because I have been to the best already. I had no one in my family help me at all to fill out the papers to go to that college either, but I knew that they were proud of me. When we got to Bismarck it was like a whole new door had opened up for me. I had to find directions to the place, but I found it after we got a bite to eat. When I got to that college the counselors got a house signed up for me right away. My cousin stayed the night at my house before she had to catch a bus back home to Washington State the next day. I took her to the bus depot. We gave

each other a hug, and she also gave my children a hug before she left. It was so sad to see her leave! We were alone, no other Yakama in sight. I was a bit frightened to go back on campus because we had a week before school started. I have always been not afraid to meet new people, but I was so far away from the place where I have been raised. I also got to thinking that I had to do the same thing when I went down to college in Sante Fe, New Mexico. So, I had to make a new batch of friends here also.

I got to meet a lot of real interesting people who were mostly Lakota. I got to talking to this real nice family who were from Rapid City, South Dakota. I became real good friends with the wife of that family Denise. Her husband Dino was very nice also, and their kids have befriended mine also; or my daughter anyway. My son Joshua could not walk yet. They started school the same time I started. I also got to see this one guy who is the tallest man I have ever seen with hair that goes all the way past his knees! He is over six-feet tall. I like that in a man; a man who is not afraid of his identity. He is part of the CannonBall drum group. I could tell that he is a real quiet kept person. I also got to meet the leader of that drum group also who is very nice. I really like that tall guy I was explaining earlier, but I was afraid to tell him because of what he might think of me.

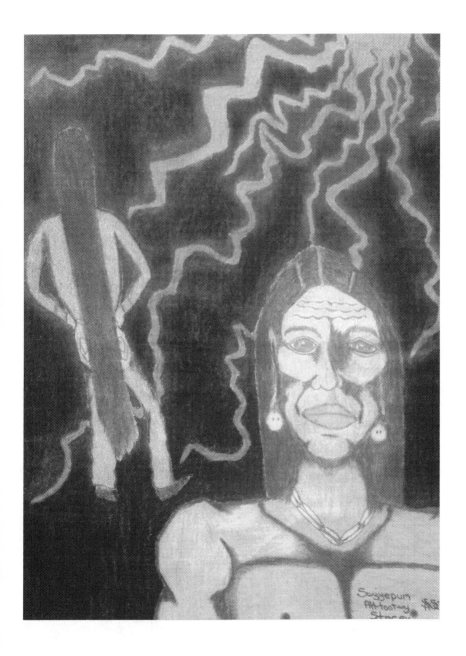

Chapter 21

AMBITIOUS ONE

I still had a real bad disability because I carried a bad right-leg limp. No one seemed to notice because all they saw was a woman who was not willing to give up on life. I just cared about getting on with my education. I had a great time there in Bismarck getting to know new people. There were people there from Utah, Oklahoma and Washington State besides the different kinds of people there from North and South Dakota. I thought that my art classes would be hard, but it wasn't hard after we got to know the instructors. I majored in the Art Marketing Degree. That program had the best instructor in the state, and he became just like my father because he would understand any kind of pain I was going through. I had great classmates also who had different talents.

As January was coming up, our instructor put the idea in our heads of building a sculpture for a park along the river. We all thought it was a great idea, but our instructor Wayne had a lot of things he had to do even before we could get started on that. The classes were pretty easy; watercolor, painting in acrylic, sketching with different kinds of art pencils the first semester, then working with a different instructor the next semester that worked in the Graphics Arts department and had us make a book on

what we wanted, and read it to the elementary kids. We had a good time that school year. I even went to A.I.H.E.C. in that first school year I was there in Billings, Montana. I went there in the writing department, and also entered a couple of my pieces in the art department.

I took my kids back to the Valley of Washington State where my family is from because it was too hard to get a babysitter that I can trust back in Bismarck. Before I took the kids back my van had to have an oil change.

I met this great guy who fixed my car just as winter was getting over. I got to go over to his house the night before the kids and I left to take them back. What I liked about him is that he wasn't that all anxious to be jumping in my pants. I have never met a guy who didn't want to get serious on a first date. We talked and talked all night long. Where we really got to talking was this bar he likes to go to so he can calm down after a day of working on cars.

I read him a story that tells about my life and how I was bought up; and he was amazed that a person who has been through so much can talk so freely about it! That really struck his fancy because he had a trouble- some childhood also, which he is good at keeping hidden.

He was too scared to give me a kiss, so he kept on looking at the floor when we would make eye contact. He timidly moves his head by mine, and reaches out his lips to slightly give me a peck on the cheek. We were playing around with our lips on each others' faces until we really got down to it.

Then, he got to holding me making sure that no other guy would take me away from him. He escorted me to the restroom and waited by the door for me to come out.

As the nights wore on AIHEC was coming up. It was to be held in Billings, Montana the year of 2004. He saw me off with a great big kiss before I departed on the bus. Billings was a great place to be at; Natives were there from all over the country. I have a friend who got to Tribes the same time I did, Denise. My friend Denise went to AIHEC in the Criminal Justice Field. I entered the art contest with two of my drawings, and in the writing department. I did good there.

When I got back from AIHEC, there was my favorite love waiting for the bus to pull up in Tribes driveway. After awhile he just didn't want to get too serious because we were raised the same, but different. He is a Military Veteran. He didn't want to get too serious because some bad things have happened already. While we were sleeping one night in bed together, he punched me real hard in the heart. He didn't realize he had done that until he had woke up a few seconds later to see me gasping for air.

Another night while we were sleeping, he punched me right in the lips causing blood to squirt out making me instantly try to cradle my mouth with my hands that had blood flowing downward quickly. I tried to call his name, and he got up striking fiercely at the air with his eyes closed. When he came to a few seconds later, he felt sorry for what he had done and got me a towel to stop the bleeding.

I still went back to him because I felt worse, considering all the pain I went through physically, and emotionally. He treated me the best that any guy has ever done, it's just the past that sneaks up on him every night. I didn't want to leave him. I wrote a poem about him, but it is gone now. I can only say this man's initials are, J.C. because I know that he would not want me to say his name. This happened right when Spring Break was over.

Chapter 22

GREAT HARD WORK

It was summer break, and we had a design to do for the Co-Ed Dorm building. It was hot that time, so we had to find the best shade that we could find. The plans were made with the park committee, and the Lewis and Clark committee to build the sculpture, but we just had to wait for the supplies. So, we worked on the designs for both sides of the dorm while we were waiting. We were glad when we finally got that finished up with in the beginning of summer- break. It was not very hard for the art students, but a lot of work went into it.

It was not until the end of July that we finally got the supplies to work on the sculpture. In the beginning of the year we had two students make a dummy-sculpture of what the sculpture is going to look like. All the students got to decide with the instructor what we were going to sculpt, and we all decided to do a sculpture of the ThunderBird; the school-mascot. The class decided to do a ThunderBird in all4-directions. We got to see the building that we would work on the sculpture in not far from campus, and the men who would teach us hands-on the equipment we will have to use. We all showed up as a big semi-truck pulled into the building. The truck was full

of 4" by 8" Styrofoam blocks. There were two- students in our class who were not going to work on the sculpture the summer-break because they were going to go home. Those of us who were going to be there to work on the sculpture helped unload the blocks.

It wasn't long before we began to work on the sculpture in which we got paid an 8-hour day. It didn't seem like we would ever get through sculpting; we got tired of having to stand in front of a big fan at the end of each work day to blow the Styrofoam off; we used rasps different kinds of materials to sculpt the ThunderBirds. We also had two-students to sculpt the heads starting out with a hot-wire, and a student to sculpt the claws. The other students had the foundation of the sculpture to work on. We put in every extra moment that we could to work on that sculpture. We also had one of the students photograph each part of the work that we did. As we were doing one head the instructor didn't like it because he said that it looked too mean, but I said that I liked it, and we kept on working on it.

After we did the sculpting, it was coated in every inch of it with cement. We didn't intend on the sculpture to be so big. We had to go back within the next few days to coat it in another coat of cement mixed with light-blue in acrylic, then we added darker shades of blue. It was looking so cool as we worked on it.

I can even remember this one time when we got off work while the wind was blowing so hard from the east. I was riding my bike that had a cart attached to it for Joshua. There was also a very big storm that was coming in from the west. It was very hard to ride my bike against the wind back to campus while there was a big storm coming in from the west. I even had to get off my bike and push it because it was too hard for me to ride. I kept

telling Taman'wixla ux'wayou, ux'wayou(wait, wait) until I get back to campus to pick up my kids from daycare. It was very hard for me to get back to campus, but I got there as the storm was right over my head. The wind was very hard there, and the lightening was streaking everywhere, but I told Taman'wixla to wait until I got home. I picked up my kids at daycare and the weather was the worse I ever seen! We made it home to where I put my bike alongside the house. It didn't start raining until we all set foot inside the house. The electricity went off that scared my children, but I had all three of us cuddled up on the recliner singing a sacred song to ease their fright. I will never forget the time when I asked the creator to hold a storm until I got my family safely home, and he waited. It wasn't until the end of August that we started to get to the end of the sculpture.

Chapter 23

ONCE IN A LIFETIME CHANCE

We were already beginning a new school year and we were still getting paid for working on the sculpture. It was 2004 now. I kept on keeping in contact with my good friends on the rez', and my family. I missed them so much that I began to pay down on a train ticket for my kids and I to go home for Christmas break.

We were finally finished with the sculpture, and we were going to have it stand in the KeelBoat Park by the river. On October, 17th. we had it dedicated to the Lewis and Clark committee. We all got to see it as it was hauled from the place where we worked on it to the park. It was very cold that day by the river, but we wouldn't miss it for the world because it was a once in a lifetime chance. We got to see what we worked on lifted off the flat-bed by forklift, and swung through the air to the place where it was designated to be. The CannonBall drum dedicated us. The sculpture was done by me and six other students in the summer of 2004. The school year went on going well as far as I could see. My son Joshua had to be in the hospital a couple of times because he had pneumonia. It was a traumatic time for us. At least he learned how to walk while we were in North Dakota. It was also very

hot over there in the summertime. I did all I could to stay in the best shape that I can because I got overweight. I would walk from our house on campus to the big-oval that was a mile wide to walk around it; maybe a couple of times. I had hoped that one of the guys I had my eye on would come and talk to me; but it was impossible because I had that terrible bad limp on my right-side leg. Who would want to be seen with me? But, I didn't think about that much because I remembered what my uncle Monte had told me before I went to North Dakota; "Just go over there to get what you want, then come back here." It wasn't so hard for me to do that because I had a dream I had to fulfill, and everyone could see my desire to learn and be the best that I can be. The big United Tribes pow-wow was held on the campus where I was going to college. It is held in the middle of the big-oval I would go walking around.

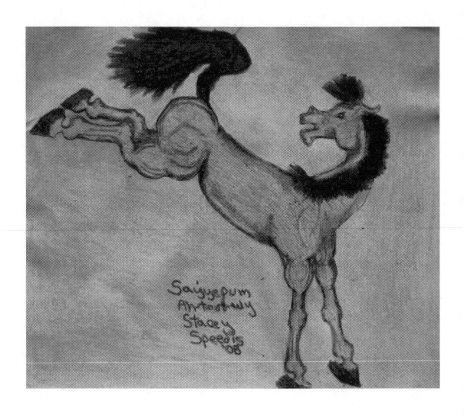

Chapter 24

THUNDER HE SPEAKS

I got with a real nice guy who is from South Dakota. He treated my kids alright I guess. I felt blessed to be with him because he is a religious man; he always did the opening prayers at certain ceremonies. He also carried a bag around with him that carried his sacred pipe. He right away moved in with me not long after we got together.

It was not long until he began to beat me because he tried to make me the woman he had always wanted. He became a ruler of me and my kids all the way up to my graduation. It seemed like that time just flew by because it felt like my wings to fly had been cut off. I couldn't look at anyone, or even talk to anyone because it always seemed like treason to him. His half-brother worked right under the president of United Tribes.

He made sure that I was good friends with his side of the family, but did not want to meet mine. He even told me that he would marry me down in South Dakota. My graduation day finally came about, and my family was supposed to be there; but all I seen from out West was my good friend Oscar Onley who helped me get into Tribes. My graduation day felt so great because I have done what I came over here to do. My boyfriend was

busy with his side of the family doing a ceremony. When I was going out of the house to get something from the car, my aunties pull into the driveway in four-rigs! I was so happy to see them. They thought that my graduation was to be that night, but I told them they missed it by three-hours. They felt so bad because they knew that it was an important day in my life. I told them it's okay that they missed it, I was just so happy to have them over here. I got in our rig with my kids and we all drove to KeelBoat Park where the sculpture we built was at. They didn't know that it was so big, and that seven-art students built it from a hands-on process. They took pictures of me and the kids by it, with them by it and some of them on it. I also showed them the plaque where all our names were placed, and it also showed where we are from. It was a great deal for me. I introduced them to my instructor. They wanted to stay at my house for the night. My boyfriend understood and went to go and stay with his sister.

At the house I cooked dinner for them. My kids had fun playing with their cousins. What amazed me is that they cleaned up for me! I guess it is a way for thanking me because whenever I stayed at one of their houses I cleaned up for them. After they got done cleaning up they cleared off the table to hand out gifts. The first thing I was handed was a wooden horse that had the Speedis Owl on it. I was given other gifts too, but I can never forget the most beautiful gift that goes to one in high honor I say; a Pendleton shawl. I was so proud of that. My auntie told me that I can do whatever I want, and that they are so proud of me.

They spent the night at our house before they started their journey back home. I felt I needed to be with them, so I decided to go back with them. I was getting all our stuff packed to go with them. I told my boyfriend, but he said he had to wait a few days for a check. I already

told my family that I was going to marry him because I thought that he was the one. My cousin was going to be the wedding-coordinator. She had it set for right on my birthday at the Ft. Simcoe State Park. He didn't have a car, so I left my van because I had a trusting heart. He gave me a kiss as we headed out back to Washington.

We had a great journey; as we reached the top of North Dakota and stopped at a rest stop, we saw a huge buffalo. We stopped at some other good places, but I still kept worrying about my car. Was I going to trust him driving it over? He doesn't even have a license. As we got back to the Valley, I thought that it was going to be great. I figured it was going to be better because I graduated from college. But, there wasn't anything better. Nothing had changed. I thought I would have a house and everything. Until the wedding I was going to stay with my auntie in Brownstown. We had to stay out in their old house before they're old house. I thought that was great because we were used to staying outdoors; it was that kind of weather where it was good to be out at night. The weather was a bit cold, but we had a lot of blankets. The next morning was real bad because when I combed out my daughters' hair, it had a few big ticks in it. My son told me that he found a few on him too. I even found a couple on myself too. My boyfriend didn't come over from North Dakota until about three-weeks later. I had to cancel the wedding, but I didn't feel too bad because I felt like it wasn't the time yet. My cousin made me a nice set of wing-dresses for me and my bridesmaids, and a nice ribbon shirt for my boyfriend too. When he finally did arrive, he didn't like the living conditions we had to stay in. We moved all our stuff back into the van and stayed that night at the Best Western.

He didn't even feel real bad that he missed the wedding. He didn't even really like my family. He got us

heading back to North Dakota with him. He wanted us to get married back where he was from. I just remembered what my grandma had bought me up knowing, "You have to go where your man goes." I thought that we were doing the right thing. When we got back to Bismarck, we were moved out of the house on campus. I went and asked the maintenance crew where our belongings were, and they told me that they were down in the basement of one of their sheds. It had a long stair-way that we had to go up and down many times. I tried to find the stuff I got for my graduation, but I couldn't find any. My boyfriend told me that probably his sister got into the storeroom and hawked the items that were missing. I felt totally shot down because the stuff that were missing had sentimental feelings for me.

I applied for housing back there in Bismarck. While we were waiting we had to go and stay with his mom in McGlauphin, South Dakota. I didn't like that at all because his mom's house had cock-roaches real bad. She was a mean old snapping turtle it seemed. My kids didn't like her that well either because she treated them bad also. We just had to pretend to like where we were staying. The storms where real bad over there because they were on the plains, there were no hills to hide behind. The storms came so bad because they came from the west. All the people in the house had to go down in the basement when the wind got too fierce. I just got to love the storms that came over there because they can be so vicious. While we were in Bismarck, I can even remember being sideswiped by a tornado.

We didn't have a wedding planned. The beatings continued to where one was coming every day. We finally got to move into our own house; I mean it was his sister's house. She was staying with her boyfriend. It was a house just to the west of McGlauphin. It was so far out in

the country that we couldn't even get to a store. My kids loved to play out there because it had a nice yard.

This one morning we woke up, and I didn't even feel like having sex with him because it was not a fun- thing. He was too-serious. As I made a breakfast and I called the kids into eat he comes out of the room. He says something and I corrected him, which must've been bad because he struck me hard on the head. I was just too tired of him hitting me, so I stood up real fast just daring him to hit me again. He hits me again on the side of the head, but I stood my ground. He got real mad and started to punch me to where I hit the ground. What makes the situation worse is that my kids had to be a witness to the beating I was taking. I know that they will always remember that because even I can remember my mom getting beat up when we were bitty-ones. They were crying as they seen me hit the floor.

I took one beating too many by that man, and I was getting very pissed off about that. I went outside with my kids and put them in the van and locked them in there while I loaded up the belongings that we had. As I was getting the last of our stuff, he jerks the car keys out of my hands and tells me that he wants me to take him to his mom's house in McGlauphin. I told him that I couldn't, but he would not give me back the keys, so I had to take him. As we got near the entrance I stop to let him off. Before he gets off he tries to give me a kiss on the lips; but I had my head faced forward to the road with a very stern look on my face. So, he gives me a kiss on the cheek and tells me that I can come back to him at anytime. He must've thought that I would be back soon because I had only an 1/8 of a tank of gas, and no one else to turn to besides my kids. But, after he got out of the van and began walking towards McGlauphin, I just peeled out of where I was

parked and headed North on the old dirt road hoping that I could get to Bismarck where I had friends.

We made it past Ft. Yates, and CannonBall, just Bismarck to get to. I was amazed at each town that we passed because when we reached Bismarck we were just going on fumes. We made it all the way to Memorial Bridge not far from United Tribes campus! That van must've wanted to get away from South Dakota as bad as we did. I called up my good friend that works at Tribes because we needed gas. She got my other friend who works at Tribes in the maintenance department to get in his work truck and bring us five-gallons of gas. Our van had almost all of our stuff, so it was pretty packed. My friend let us stay the night at her house just north in Bismarck. She absolutely loved my kids because they are so adorable, and listen very well. She cooked a good dinner for us as we slept so peacefully in her house with her husband and kids.

The next day she was doing some planning on where we should go next because we could not stay at her house all the time. She got us into a place for women who have been beaten by their special- other. The place is called, "Adult Abusive Resource Center." It is here in Bismarck. I didn't know how else I could thank my friend for getting us into a place like that.

Other women were there with their kids, so my kids had other kids to have fun with. I was attending counseling because I was another victim. Everything was going great, until night came. That man I was with seriously hurt me physically, emotionally and mentally. I began fighting with my pillows punching them around making my blankets land on the floor. I'd be screaming and yelling wondering how I could be in that situation again. I told my counselor what happens at night-time, and she told

me that all the women who stay there go through the same thing. I was afraid to go to sleep because I would see him again. Myself having them dreams went on for about a couple of weeks until I finally stopped punching my pillows.

I didn't know what else to do because my heart still hurt. What I can do is write a good poem about a person after I have gotten to know that person. I began to write about him, and the perfect poem just came from my soul. The words just rolled off my tongue so naturally I was amazed on how fast I wrote it. It made my heart feel so much lighter and free, and I could smile without having to paint it on my face. The poem I wrote is called, "Thunder He Speaks." After I wrote it, I showed it to a few people, and they wondered how I got him into my poem because it sounded exactly like him. The poem I wrote is right here:

Thunder He Speaks

There is this man
 with destruction for his name.
He would try to control me constantly,
 and get my kids to do the same.

This man turned me on
 beyond extravagant belief.
His eyelashes, his soothing voice,
 captured my heart with relief.

He captured my soul
 to where I had nowhere to run.
Left my mind dully-empty
 before episode even begun.

He controls the thunder,
 lightening and rain.
Can make the most beautiful day,
 dark gray and insane.

I thought he was the greatest man,
 no one could possibly beat.
Until the time his throws knocked me senseless,
 to the point where I felt like thrown meat.

He would tell me, "You must be a proper woman
 beneath my eyes.
One who will listen to, and obey me,
 do your best to hide the lies."

He beat me up so bad,
 trying to force his love into my soul.
Makes me pretend to love his lies,
 whereas he rubbed my will like a coal.

To make my heart melt,
 a flash of lightening would touch my heart.
His soul could wrap me in a bundle,
 and shoot me like a dart.

There was this dark-blue
 around the pupil of his eyes,
They carried un-trust and deception,
 filled horribly with lies.

Many scars on his body
 That were hidden to my perception.
He tells the story of how he got them,
 and shows them off as a decoration.

There was this sudden pain in his legs,
 he had no way to feel.
He had paralysis leg down,
 that twisted his mind like a reel.

He struck my body with vengeance,
 in every hurtful part known to man.
Got pissed off because he couldn't have my spirit,
just looked at the horizon and ran.

He is a traditional dancer of many,
 aboard the long pow-wow trail.
Paints his face black and yellow,
 hiding his trickery under a veil.
What has happened between us,
leaves my heart totally in pieces.
Makes my whole world fall apart,
 and time completely ceases.

The horses are highly revered
 in their part of the country.
I show great pride in them,
 because it is them who protect me.

This man don't want me to say his name,
 because he knows that I am fighting.
He knows that I want him to stay away but,
 I know that he can hear my writing.

Chapter 25

PAINTED SMILE

Writing that poem was very therapeutic for my soul. Yes, he comes back every now and then in my dreams and makes me still think we are together, but I wake up with that fear in my heart thinking I let my children down and went back to him, and my family. Dreams seem so real after a person has been in a real bad situation as I have, and have been able to come through it. Writing was my greatest power because of the way I was raised, and every person has a power of their own; they just have to find it.

When I went back to Bismarck in June, I filled out an application with Burleigh County Housing. When I was only in that battered women's shelter less than 3-weeks, I got an apartment downtown at Washington Courts. That was one of the worst places in Bismarck, but it was a roof over our head. After I moved in there, I got a job over at Tribes being a Resident Assistant. It was a job where I had to work shift-time; that is, whenever they needed me. It was rough, and I had to miss work a lot because of my kids; it cost a lot of money for babysitters. If anyone babysat my kids, they had to really take in a lot of culture because even though we were far from home, we spoke our Native tongue as much as we could. All

the people who babysat my kids loved them so much because they listened so well, and were very respectful. They even made gifts for them to get through the hard winter because it was very cold over there. My daughter really loved it over there because of the school that she went to right on campus; it had after school activities all week throughout the school year. She will never forget them.

I got with this man a little while who was the brother of a famous flute player; my daughter really loved the flute player because she liked the way he played. They were from up in Newtown, North Dakota. We drove there from Bismarck so my boyfriend could see his brother. It took us a few hours to get there. We got there late at night, and his brother was having a drinking party. We found out what he was really like. His brother also drank, but I just stayed in the room with the kids.

After I had that job for a school year, I tried my best to show up there because I had my children to look out for. The graduation finally was coming up, and I could not work the last two-weeks because I didn't have a trustworthy babysitter. But, it was okay, I got to spend a lot more time with my kids. I haven't been in a relationship really ever since I have been with that guy I wrote the poem about because I was too afraid to get hurt like that again. My job ended and I didn't have no money to help us survive, so I did what my cousin does and made myself an at home babysitter. I did real good for the first couple of weeks until I started to get taken advantage of because of my niceness. I was really home-sick at that time; I just wanted to get out of Bismarck and never go back there; even though Bismarck holds the best college I have ever been to. I seriously wanted to leave by the time it was late July, but I only got paid for babysitting at the end of each month because we were getting paid

by the state. I only received one check since I started working in June. I was seriously saving up money to go home because it cost about five-hundred dollars to go home because of the gas it cost to put in my Cadillac I was given by the Adult Abusive Resource Center.

At the apartment we were staying at was a place for the party-people, those who wanted to have a good time. I really wanted to move out of there because the environment was not safe for my kids. We started by that time at the end of July to throw out the stuff we didn't use; and it was kind of a bit hard because we stayed on the second floor. We didn't let that stop us though. I was the main one hauling out the old stuff because my little-ones were too small to work. My daughter helped me now and then. The day before I get money was finally here, and we had almost all the stuff out that we did not want or use. It was very hot that morning as it had been for quite a bit of days. We had the fan blowing up in our room that made the whole house cool because it was a big fan. On that morning I had the kids stay inside because it was too hot for them to go and play in the playground. I still had to haul our belongings out to the garbage on the side of the building making each step I took outside of the room seem like I was hauling blocks of cement. I kept on forging on though as the sun beat unmercifully down on my head whenever I went outside. After about an hour of working I decided it was time to take a break, and I really deserved it because I was starting to get shaky; I needed to have a little bit of a snack.

Chapter 26

FRIENDS AT HEART

On the day we were going to leave after I got my check I told the landlord of the apartments that he can give my furniture back to the second-hand store I got them from. He tells me that I must take them myself, but I already had our stuff we were going to take with us packed up in the Cadillac, and had the trunk opened packed up with more stuff that had to be tied down. I didn't want to do something like that because we would have to stay here another day. After I was done talking to him, I just hurried up my children to pack up their belonging they were going to take with them in the car and got the --- out of that place.

I couldn't believe we were finally getting out of that place until we were out of the city. It was a very hard place to leave because we have been there for three-years. Gosh, we were finally going home. I have been keeping in good contact with a married couple who I met the same year I started at Tribes, and they had moved to Auburn, Washington. I called them before I left the apartments, and they told us to meet them in Cour De Lene, Idaho to show us where they stay because I have never been to Auburn. I didn't believe it, we were

finally out of the state, and getting ready to go through one of the biggest states in this country-Montana. It was very beautiful. We had to stop and rest at a rest-stop because we didn't want to spend any money we had on a hotel room. We only had to sleep in the car, which didn't scare us because we were used to sleeping in the car. We got up early the next morning and got ready to head through the top of Idaho which only took about an hour and a half. Our friends were at a gas station in Cour De Lene who we followed behind. We didn't have to gas up there because we had a full tank from filling up in Butte. We followed them for about three hours around there. We came to Ellensburg in which we were only about an hour from our Rez', but we turned around and started to head North again. Now this part of the state I did not know.

We drove for a few hours more where we had nothing to see but a whole bunch of other headlights. They knew where they were going though. We ended up in this place called Federal Way; I had never heard of it. They went back to the place where they were staying and asked if we could stay there because they were guests. We could not stay there, so they began to look for a place in town. We were all driving around and didn't really know where to go. They drove by this arbor that had a bunch of cars and trailers parked by it. They start laughing and say they will buy us a tent and let us camp out. As they were laughing, they couldn't understand why we weren't? I tell them, "We're not scared to camp out, we're used to it." So, they took us to Wal-Mart in Federal Way I think, and we bought a tent because we had everything to camp out packed up in the car.

We slept peacefully that night. It was noisy, but it was a like a pow-wow ground, we were used to it. We had

a little lamp and everything. Our friends went back to where they were staying.

My children woke me up in the brisk, autumn morning among the people who were rushing around to get to the showers before the hot water runs out. I wanted to get my kids and I cleaned up because we had a long journey of endless highways. We were looking for some kind of building that the showers should be in, but we found the showers after we looked around for awhile in the back of a semi-truck. That was the first gathering I have been to that had showers in a truck, but I wasn't going to argue about it as I hurried my bitty-ones so we could get cleaned up.

After the shower, there was a place outside the truck where we could put our shoes on and brush our teeth. My kids had their shoes on and were ready to play. As I was tying my shoelaces I yell at the kids telling them we must brush our teeth. I was getting up to go by the sink when my daughter just so happened to call my name, and I heard a voice behind me say, "Stacey?"

I turned around to see who it was, and it was my favorite instructor who I met when I attended the Institute of American Indian Arts. Her name is Annie. I cleaned our teeth and introduced her to my children. She absolutely fell in love with them because they listened to her so well, and were very happy to meet her because they knew she had a great effect in my life. She gave us all gifts and spent the day with us.

My friend Annie told me that we were at the Muckleshoot Canoe Gathering. It was our first time being at one of them, it was very interesting. My children had a very good time. And, it just so happened that my carburetor went out on our Cadillac. I didn't know who to come in contact with to fix the car because I

was almost out of money, and I didn't want to stay there because I had this urge to get home. But, my friends who stayed there in Auburn got me the best mechanic on the rez' to come and fix my car. I only had to pay a little for the part, and then he got it fixed. I was so happy as we stayed with our friend to watch the rest of the canoe gathering. I asked her why she was so far up North, and she tells me that she is an instructor at the college of British Columbia. She told me that she tells people about me, and called me a very inspirational person. I never knew that I could be that way even though I have survived a lot of happenings.

Chapter 27

KEEP ON THE GO

We were getting ready to head for home the next day, so we had our friends we had to say goodbye to. It was very hard to leave Annie, but she gave me her phone number. Our friends that we were going to stay with in Auburn also gave us their number to give them a call once in a bit. As we were getting home it took us a couple of hours before we recognized familiar territory; we reached Ellensburg which was about an hour from our rez'. I believed there was going to be a big difference because I graduated from a college that was far away. We got to my auntie's house in White Swan not too long after sunset. They did not even expect us, but my auntie said that we can stay there anytime.

I thought it was kind of weird because nothing had changed; everyone was still the same as when I left them. Why did I come back? Why did I leave my friends over there? Well, I'll tell you, I came back because my rent was going to go up another three-hundred dollars to where it would make it impossible to have a fun-life, and I really did not have that much friends over there ever since I stopped going to college. It got rough living over there in Bismarck, so I came home thinking there would

be a change. Here we are staying with our auntie in White Swan again in which things seemed to be harder. There was a corner cleared, or one little part of a comer cleared for us to put our belongings.

So, we were home again, nothing changed. The people were still the same. The only thing different was that I saw my good friend who I have known for a long time who said that she would get me a job. I didn't really know for what, I just thought that I needed a job because I graduated from a two-year college. I had to get Tribes paid off for housing otherwise they wouldn't give me my transcripts. My tuition was paid for by the Yakama tribe, but the housing was left up to me. I had about a week until I started my job; I was a Substitute Teacher Assistant for the Head start.

The job was working with little kids. My job began in August of 2006. My son Joshua was old enough to begin head start the year I got the job. In my job I was required to go to White Swan, Wapato or Toppenish; wherever I was needed. I love to work with children, but I won't let them have their way. It was okay setting table, cleaning it, and doing anything the teacher told me to. I was good at not getting into any arguments. I held that job for two school-years. I wasn't getting tired of it, just getting tired of being one of the most dependable substitutes.

It was now the summer of 2006, the first summer of my being laid-off until the school year starts again. I was having a little bit of a difficult time with my family. I am a person who was raised without parents. We were raised by our grandparents. I never had a mom or dad to look up to give me advice. That is what I have been looking for all these years, someone who I can call mom and dad. The 4th of July finally came about. We usually move to the Indian encampment down in Toppenish, but we

just stayed at home because the village seems to be disappearing every year. My auntie, and her children were getting ready to go down to the parade in Toppenish. I cleaned up the house as usual, and was braiding my son's hair in the kitchen. Something really put her on her bad-side about us because she begins to swear about a few pieces of candy on the floor. She begins to swear at my son while his sister was scared of her standing right by him. That really pissed me off because she was yelling at my kids. I yell at her not to be swearing at them, and she comes to me and stands right in front and just stares at me with a look of hatred in her eyes just daring me to say something else. I didn't say anything, but I stood my ground. I wasn't going to let her think that she had me to the floor as I have been treated in the past.

My auntie just looked at me for a few seconds before she got her family packed up in their rig to head downtown. I finished my son's hair and gathered my children so we could talk in the living room; we didn't even sit down. My son could not talk yet so I asked my daughter Ranetta, "Are you getting tired of being treated like this?" She looks around the house and then looks up at me shaking her head to say yes. We were always made to feel the lowest because it was not our house. We were used to moving around, so I packed up what little belongings that we had in the Cadillac and got away from there.

We decided to go to the parade downtown. I didn't want to see my family, so we parked far away from where they might be. The parade was okay I guess, at least my kids got a little bit of candy. We hardly had any money on us either. We decided to go down to the pow-wow. It was going to start in about an hour. Our dad was still the m.c. for the village. We were eating at the main breakfast stand when I saw our dad just as we were leaving. I know that he saw us, but he acted like we were not even alive. I

wouldn't talk to him anyway. I just took my kids on carnival rides, and got my son's picture on a pony. I would've got my daughter, but she would be a bit heavy for the pony. After awhile we decided to leave the grounds.

Chapter 28

FIGHTS NEVER END

I didn't really know where we would go, but I've been keeping in contact with our good friends Chris and Mary. They suggested that we go to the Mckinley Mission. They took us right in and gave us a room to stay in as long as we needed it. It was good to have a place to stay for a few days, but I have been keeping in contact also with the man who I called father, who I met when I was going to college down in Sante Fe. He invited my kids and me to go to his house in ClearWater, Idaho. It was there where he and the mother of his children stayed. I haven't been to that part of the country in a long time, but I followed the instructions he left me over the phone. We stayed there about 3-days until I felt that we had to be moving on. He said that we can come back whenever we want to because he was going to let us stay there, but I felt too uncomfortable there. I went back to the Valley wondering where we could go, and I got it arranged so we could stay in a shelter for battered women in Yakima.

We were at that place for almost three-weeks until the beginning of August. My other auntie who stays in Brownstown called me up to see if we could watch the house while they were at Omak. I agreed, and decided that we should move in with them because school

was about to start, and I wanted my daughter to go to school with other Natives. My auntie happily agreed to let us move in. My auntie said that the house had been broken in to Treaty Day Weekend in June, and they didn't want to leave it unattended. It was scary there all that weekend alone, but when we were too scared I had the kids cuddle up by the altar in the living room while I kept my eyes on the window and doors. Well, they came back from the rodeo and life just went on as usual. I started my job as a Substitute T.A. again. My daughter got all registered to go to school again too. We began our rounds of going to pow-wows in the fall time. My auntie was getting tired of having to open the door for us on a very cool night about one, or one-thirty. This one morning after the Indian Summer Celebration she gives me a number to call for a trailer to rent down in White Swan; which basically meant that she was getting tired of us too. I believe that my cousin who is a couple of years older than I am was getting tired of me too because no matter how hard she tried, she couldn't get me drunk. I go to work after my auntie leaves for work. I only worked a half-a-day because I had business to take care of. I couldn't get a hold of the trailer courts, so I went out there in person. They told me that they had only one trailer, but they wouldn't have it up for rent because it needed to be cleaned. I was so blessed, I said that I would clean it. The landlord said that he would knock off the deposit if I would do something like that.

Yippee! We were going to get out of my auntie's house. My daughter, son and me were to keep all our belongings in one little closet. We had to sleep on the living room floor where we had to fold our blankets every morning. As I went back to the house in Brownstown, my cousin was there with the children she watched for daycare. I bought a Bronco to ride beside my Cadillac. I got all of our belongings inside the Bronco and Cadillac.

My daughter still had to get home from school. I had the Cadillac parked where it would not be hit, and I was waiting inside the Bronco in front of the house. My son was playing with his little cousins' right in front of the Bronco. There was their old blue-truck in front of the house. The kids were playing in the back of it. All of a sudden this firework goes off! It lands right by the Bronco's tire. All the kids looked scared because it was one of them who lit it off. My cousin comes screaming out of the house wondering who the ---- lit off that firework? She right away comes up to my son and says, "I suppose it was you, you --- ------ little brat!" I got out of the car and yelled at her not to be taking the Lords name in vain. She gets pissed off and comes over to me. My son was below me crying on my leg with his arms wrapped around it. She gets mad at me and tells me to get the ---- off her property. I thought the property was my auntie's, but the land went to the first oldest child after my uncle had left this world. I told her I have to wait until my daughter gets home from school. I was planning on moving into the trailer courts. I was still shaken up by what had happened, and called the tribal police after she went inside. I heard her yelling at me to leave before she goes out the back door. I will say she either had a few to drink, or she was suffering from a hangover because she was drinking the night before. She comes back by my rig with a club. She tells me to get off her property, or she'll beat me off. She gave me the choice. She raised her club in a striking position ready to strike. I knew that she would have hit me, and felt no remorse. I started up the rig, and she puts down the club and goes in the house swearing. As I was about to pull the rig out, the tribal police pulls in the driveway. My son was still crying as I turn off the rig. The police show up and I tell them what had happened. My daughter was just getting home from school. I got her, and the police said they couldn't do anything because it was her property.

They could only tell me to go to emergency housing at the agency.

They escorted us to Toppenish where I went to the agency, or I was told to go behind the Tribal School. Like that was any help to me in my time of crisis. The people who worked there told me to go to housing at the agency; I didn't even know that there was a housing at the agency. I went there expecting for there to be nothing that could help my family. When I asked for emergency housing I heard just what I expected to from the lady behind the desk, that there was no emergency housing available; but she got an Email just at that moment from Oscar Olney. He had written that he knows a landlord who has two-apartments available in Toppenish. The secretary had dialed that number as I held my breath waiting for a good response. The landlord had said that there were apartments available, but he would not be able to meet with me until the next morning. He was wondering where we would stay, and I told him that we could sleep in the car. He had said that it was a family emergency that was holding him back. I called up my good Christian friends Chris and Mary and told them the good news. They didn't want us three to sleep in the car, so they got one-night at Best Western. God bless them, they really treated us well. When I got to the Best Western, It slipped my mind at the time that my cousin had kicked-in my door. I called the tribal police again to tell them of the incident. They had told me that they could have taken her in at the time if I told them everything, but I was too shaken up at the time. The only thing that they could do was make a report. That really put my mood down because she doesn't deserve to be a babysitter with the way that she acts.

That night that we stayed at the Best Western was a very relaxing time that we just needed. I decided to

go swimming with my kids. It is not every night we can stay at Best Western. There was a spa in the pool-room, and I thought it was too hot. But my daughter said that I should try it, and I decided also that I should give it a try. I stepped in there up to my knees to where the rest of my body followed. When it got up to my chin I felt a great wonder of relaxation that made me close my eyes to savor the moment. I have never, ever felt that way before, and I didn't want the feeling to go away. That night was just heaven to me. That experience was just what I needed to help ease the stress that my heart was going through. I stayed almost that whole night in the spa. I of course got out a few times to go and play with the kids in the other pool, and also invited them in to try the spa. We had just a beautiful night. We stayed up late watching the cable TV. We ate breakfast the next morning when it was almost time for us to check out. I called up my good friends and cried while I told them that the night away from everyone, and everything was just what we needed.

Chapter 29

SACRED ROAD

When we met the landlord he showed us the apartments. The first one was behind Safeway; it was okay. I wanted to stay there because it didn't have anything to do with my family. The second apartment he showed us was at 502 E lst. It was in a completely Hispanic neighborhood, but the apartment was a two-story duplex. My children really fell in love with that place because it is very nice. We didn't have to worry about garbage or cutting the lawn because it is done by the town.

When we moved there my daughter had to transfer schools, and my son just had to transfer head starts. My daughter had to begin school at Valley View. She felt like an odd-ball because it was hard for her to make any friends in the completely Hispanic school. I met with the teachers and principal who were very nice. There were a few Native kids that went there, but it was hard for my daughter because they were in different grade levels.

As time wore on I still held my job at the head start. There were even times when I had to take my daughter with me because there was a shortage of subs. Almost every week that went by we met a different church-group from across the states, or in the state from up North. I got

my daughter and son very involved with them because they were very friendly. My good friends Chris and Mary, I have known them since before my son could walk. Joshua is just a few years younger than their son David; they grew up together. My son Joshua also got his name changed to Scwe'lelut Joshua. I have seen his father, but Scwe'lelut is scared of him.

I was still getting around in our old Cadillac. I was amazed it made it this far; but it was really breaking down. None of the windows would work in it at all. We were dressed up really cool, but we had to hold our breaths every time that we opened up the car because we would feel that swish of hot air to our faces. But, we were sure to make it to Bible study every Tuesday night. It was very good for our souls to be very involved with the church groups. I did my artwork all summer which made the church groups happy because they were happy to see an artist who has been through so much. I can even remember doing a piece when there was a fire up near Mt. Adams. I just drew what I saw; the piece came out very beautiful.

The end of the Summer-church groups that were coming to visit, and work on people's houses that needed it were coming to an end for that year. We were attending one of the last Bible studies with them at the Toppenish Creek LongHouse. As we were getting ready to leave my good friend Dave told me something that was hard for me to believe; he told me that he will give me that gold van parked in front of the longhouse. He knew that the old Cadillac the kids and me were riding in was falling apart because he has worked on it many times. Dave was an intern for Chris for the summer. Dave is originally from Florida. He told me that the van was getting worked on right now, and told me to pick it up that following week. He also said that it just needs an oil change, and a transmission-oil change.

Chapter 30

FIND MY SOUL

At the time when we went to go and pick it up I couldn't believe how beautiful it was. My two-bitty ones were the first ones in it and were excited that it was really ours. My cousin was the other driver that I had to drive my Cadillac back to where I stayed in Toppenish. All the seat-belts in the van worked, plus all the windows too. I had to have the van parked in our parking-lot because I knew I couldn't drive it until I got all the paper work, and licensing bill paid to get the van put in my name. I right away got the oil-change, and transmission-oil change so that we could start enjoying it. I told myself that I will keep it in the best of shape. I clearly can see that the van I was given is truly a gift from GOD.

The school year was going to start up again this fall. My daughter Ranetta will be in 4th grade at the Valley View Elementary. My son graduated from Headstart last May and will be starting Kindergarten this year. He was kind of scared at the beginning of the year because it was so different from headstart, but he is a person who is easy to make friends with. He also listens well too. My daughter had almost the same classmates as she had the previous year.

Well, I decided not to work at the headstart that year because having a job was too strenuous of a thing at this time. I only found out last February that I had PTSD really chronic because I had witnessed a lot of traumatic things in my lifetime, and have had traumatic things happen to me as well. I have been living off of Supplemental Security Income for almost a year, and selling a little bit of my artwork. I really needed to take time off of work to really find "me". I lost part of myself mentally being in that horse riding accident.

We still have been attending Bible study, and going to longhouses, memorials and round-dances. The only reason why we are invited is because people know that my children and I love to dance, but also must keep in our minds that there is a creator. I will not say which belief I believe in the most because they have helped me so much; I was raised in the longhouse as a food gatherer believing in Taman' wixla', but also have been saved by Jesus Christ when I was all torn apart far away from our home. I have a true family; my Christian family. An older brother and sister who are there for us whenever we need them.

I have attended my first wedding a few weekends ago, and I thought it was the most beautiful thing that I have ever seen. I'm 33 years now. I have been invited to weddings, but never knew the importance. I cried at the wedding I attended because it was so beautiful. A man and a woman who were joined together under sacred vows of holy matrimony. I wanted right away to be married at that gathering, but I am very careful on who to choose because I do not want to be hurt by a man like I have many ways in the past.

I had to do this writing because I have wanted to do it since I was attending college down in Sante Fe. All I have

written is the truth; I know because I was the one who went through it. It is true, my family was not there for me in my time of need, but I know they still love me and my children. They can witness most of what has happened to me, but where not there mentally to see how I dealt with the traumatic things that have happened to me and my family. No, I still have not talked to my dad. Not because I am afraid, but because I will say that we are not ever going to forgive him for what he has done to us in the past. Yes, I understand that he must be forgiven because it is not good to carry hatred in your heart, but his actions have made each of his children the person that they are today.

Chapter 31

SILENT CRY FOR HELP

My little step-brother is down here in the Valley from up in Bellingham where he was raised. He fell in with the wrong crowd of family when he moved down here and spends most of his time on the streets with our older sister drinking the stuff that hurts your body. He was with my brother's wife when he came down here. I was so happy to see them because it has been so long. He was happy to see me and his older sister as well. Our older brother is in jail right now. My brother's wife used to send our little brother to sober up at my house because she knows that liquor is not allowed at our place. I let him sleep at our house, and I fed him properly. He must have thought that I would always be there for him. This one night after he has been gone for a few days he calls me up. He was in Yakima at the Greyhound Bus Depot. He was staying at the apartments just down the road from the bus depot. He asks if I can come and get him. So, I pack up my kids and we head to Yakima. After I pick him up I ask him what he is doing up here? He told me that he wants to get an apartment up there, and that he has to go to the agency to get on government assistance to help him get an apartment. He told me that he never graduated from high school, but gets a check every week from

working with the elderly. I asked him if he was going to live off of that. My son was already sleeping in the back, and my daughter was reading a book because there is a light switch in the back. I tell him he must get a job to help him support himself, but he was drunk already and I knew that he didn't hear me. I began to get mad at him. Then he raised his voice to me and says that he is just like our dad! How do I think there is going to be a change in his attitude. I got mad at him back saying that I am an example. I have gone through the same things trying to help our older brother and sister, but they are where I can't do anything no matter what. Now, I am the Na'na and he is our little brother. I have always been looked down on because I am a little sister. I told our little brother that I will be there to help him get into treatment, to get an apartment, but he has to be willing to help himself first. I got all mad because he wanted me to drop him off at the stock-yard because he had two-forties on him he had to finish because he knew that alcohol was not allowed at my house. I told him no, just throw the beer out the window. Anyway, I just left him at the roadway of the stock-yard because I did not want to drive all the way in there. He told me to call him and come pick him up the next day. I told him that I wouldn't call him, he had to call me. The last I heard another time I was going to pick him up was that his jacket was stolen, plus his cell-phone. He told me that he was tired of living in the street. I went to go and pick him up, but he would not go with me because I wouldn't let the street-woman he had found come with him. I never heard from him again.

I want to get help for my brothers' and sister. They have admitted to me that they want help. They have given up because they think they are failures. I know they can be great people, but they have to be willing to help themselves and take the steps involved to make themselves grow to maturity. I don't know how I am going to make these sayings come to reality, but it is a dream

of mine to let our dad know that he did not defeat us. Many more things have happened to me that would really touch your heart, but just tell me what you think of me so far.

Chapter 32

LEGENDS

I am an artist who has been drawing since I could hold a pencil because of the way I have been raised. I had to switch from my right-hand to my left-hand because of the accident. I am a great writer on the computer. I have always been a great writer. I am a food-gatherer, I go to longhouse every Sunday, I go to Bible study every Tuesday, my kids and I attend medicine dances because it also cleanses our mind, body and soul. We go to memorials and name-givings. I am unemployed right now because I needed time to help find myself. My children are in school right now, but whenever they need me, I am there. I have grown up without a mother and father, and know what it is like to not have that person there when you need them most. I tell my children I love them every day, and we pray to Taman'wixla' every night. We were staying in a home-less housing, but it was switched to another company. I hope I will marry into a family that will love my children and me, as much as I love him.

It is now 2009. The children and me have spent all summer getting ready for the Legends Casino Pow-wow. My son has been a candidate for the National Indian Days Pow-wow since the beginning of summer, and has

been selling raffle tickets. I had posters made up for him, and had his name announced on the radio. My daughter became a last- minute candidate for the Veterans Day Jr. Queen, and she just got her tickets at the pow- wow. It was a great weekend. I danced in a dress that I made up to not look like the other traditional dancers; instead of having long- fringes or short- fringes, I have horse- hair. I feel that is only right for me because of what I have been through with horses. I can't dance like a fancy-dancer does, but traditional dancing is too slow for me. I dance with all my heart and use every muscle in my body no matter how much it hurts me. I have been told by the leader of our longhouse that when you dance you have to be like a racehorse. Whenever I dance I imagine myself as a thoroughbred racing for its life with sweat just rolling down its body. When Saturday came about after the Jr and Teens danced, the adult categories got to do something a little bit different; a Snake Dance. It was the men who were first all holding hands, then it was the women. It was kind of a long dance, but it was fun.

There was this time on Saturday that the committee was having an Owl Dance, then a couple of Rabbit Dances. I really like to do the dances of the old times. I was standing on the east- side of the arena wondering who I can take out on the floor. As I was heading to the east-side of the arena I saw this real handsome traditional dancer who was very tall. I said to myself, "No way, he won't go out on the floor and dance with me." As tradition goes it is ladies choice. As I move closer to the floor I look to the north and see an old elder lady who is a good friend of mine. She tells me to go out on the floor and dance because she knows I love to dance also. I tell her that there is no one to dance with. She nods her head to the west at that good looking guy that I was looking at. I didn't want to disappoint the elder, so I walked up to the dancer and held my hand out. He comes over to

me as if I had an invisible rope where I caught a majestic stallion with. We just get onto the floor and begin rabbit dancing. I will admit, when I perform an old dance I'm used to being the one who takes the lead; but he had us hold our hands in a way that was different from everyone else, and he didn't dance in a straight line either. He danced swerving in and out of the line that we were in. He led every step that we took out on the dance floor, and my body just moved with his as he was leading. It was so cool that I can never forget it. We danced two-songs together. When we got done and we were shaking hands I asked him his name? He told me that his name is Hawk. I told him that was cool, and I asked him where he was from? He tells me that he is from South Dakota. We parted, but I kept watching him all weekend.

Chapter 33

WATER FIGHT

I have been going to church, and longhouse because Jesus(Tamanwixla), has been a life-saver for my kids and me. After the baptism of my friend's son, I was talking to a very good friend that I have drawn a picture for a birthday present. He looked like he has been through a lot of pain. I asked him when he wanted to pick up his picture. He said that he wanted to pick it up a long time ago, but he was in a tough situation. He was telling me that he was in a boating accident; that is why he walks like he is holding his breath. He said that probably three-ribs are broken. While we were sitting in the longhouse, he tells me that he has been under water. He tells me to look at the windows in the ceiling that were so far from where we were sitting. He says that he has been under water going down because he can see the light getting darker. He just left it at that, but I would like to talk to him some more on how it was for him to get out of the water. As we finished talking for the night I asked him if I could give him a hug and touch the part of his neck and his upper- chest where it hurt. He leans over as I give him a hug, then we parted.

Chapter 34

HEART PAIN RELEASED

Payu' kw'axla, thank you for listening to my life story to help my spirit. I know that I will encounter many more hard-ships coming in the future, but I have to wait until that time gets here. I raise my children the good way, not giving them what we have encountered unwillingly in the past.

To bring this piece of writing to an end, I will tell you what I have been doing; I have been reading Sherman's books in the past six- months, I have read two books. Really, I have read three in the past year besides doing my artwork of many media, and being the head of household. I will say, I really liked the books; he is a very straight forward writer who, when he has something on his mind he's not afraid to say it. First, when I began to read his book "Face", it took me a bit to catch on to the poem, "Volcano". The reason why it was so hard for me to catch on to was because I was only five- years old when it erupted. I will tell you the truth, no one in my family at all explained it to me on what the experience was like, I had too many bad things going on as well at that age. It's like I could see it happen as I read the poem. I would like to write it because I have to return the book to the library soon. That poem really spoke to me; telling me I've got to

let go of my past. I thought I already did that, but what I did was tuck what happened to us under a pillow. I have learned not to dwell on the past because I have two- kids who are looking up at me as a strong leader, and mainly I didn't want them to grow up without a mother as I have. I had to write this book because it will help me get over the past, but it is tucked away in my soul. My father is still alive. But, how it is now is that we don't want to believe the other one is alive; he won't dare talk to us, and I can never forgive him for what he has done to us. Will he be forever be eating at our souls? My older brother, sister and me? I would really like to see Sherman because he is my hero. He really brings out things of the heart that have been buried a long time. Reading this poem just made me cry because I have to do just that. I really liked the book "Face" Sherman, and many of his other creations; (movies and poems)

CHAPTER 35

THE BEAUTIFUL WAY

I would like to begin this chapter a different way; it was the time after a great gathering of friends. My friend and her husband and son were over here in the valley visiting from Walla Walla, Washington because they say they have no home life, and it was the Thanksgiving break. They like to go to certain gatherings over here in the valley because they go to pow-wows mainly, and their son dances grass dance on the Jr. Level.That's how my children became good friends with that family. We went up to the skate-board park in Yakima because their son has a skateboard. My kids had only scooters because they are down from the valley, where there are a lot of bull- heads to pop bike tires. They were scared to ride their scooters around the skate park because they were intimidated by the skateboarders, but it took them awhile to get used to the company. I did not have much money on me because it was the end of the month. They wanted to grab a bite to eat, but I only had enough for a couple of burgers. They were kind enough to give me enough so I can buy something to eat, mainly the kids. We had a good time just talking around while the kids were playing in the indoor playground. After about an hour we decided to head back to Toppenish. She told

me she would go by the casino. I asked her what she would do there because she had her son. She tells me that she will probably go to the doorway where she can just sit and watch her son, and I told her that I would take my kids there just so we can be out of the house. I'm not a person who will spend her time in the casino because I hate gambling.

I was there talking to her again because it was better than just sitting at home doing nothing but watching my kids play. They like to play with my friend's son, even though he is not a Native. As the night got a little bit busier for the casino, I received a call from my uncle in Pendleton. It was pretty late at night, but he said that we had to be over there for an emergency. I was kind of a bit in shock, but I knew that he needed my brother, sister and me over there because they are our people too. I knew how to find my brother because I had his phone number for his wife. They told me that they didn't have much gas in their car to go anywhere. I told them I would contact my agent to see if he can give me emergency money.

I told my brother I would pick him up because I felt this was an emergency situation. My agent called me right after I got off the phone with my brother, and he had about forty- dollars I could use to fill up my tank and make it over to Pendleton. It was about 11:30 at night. I told my good friend who I was there with, and she told me that I had better go because it was a family emergency. I gave her a hug because she knew who it was we were going to see because she knows him from the pow-wow trail. As I rounded up my kids to start the journey, I couldn't think of where to come in contact with my sister because she stayed on the streets. I went to Wapato to get the gas money and filled up at the Wolf Den. My children were just relaxing in the car because they knew that I was in a hurry, and they were used to making emergency

travels because we are a traveling family. I headed out for White Swan to pick up my brother. He calls me when I was half-way there to let me know that his wife will be going with us. After I pick them up at the Trailer Courts, I tell them that we must go home to Toppenish and pack for a few days before we head over there. They tell me they will wait for me.

I go home and spend about a half-hour packing. We headed out about one o'clock in the morning for Pendleton.

It did not take long for my kids to go to sleep because they were very tired. My brother bought along some dried deer meat from his house, plus some other snacks to keep them awake. When my uncle called me while we were at the casino he told me to go to grandpa's house in Pendleton. We took the 182. When we got just past Grandview, my uncle calls again I pull over to the side of the road in a safe spot, and he says in a very shaky voice where I could just see his tears rolling down his face as he spoke to go directly to the hospital when we reach Pendleton.

Oh, you can't tell how I was feeling; hurt, scared and confused... My brother right away wakes up his wife so she can drive because he can see that I was hurting. She takes the wheel, and we head out even faster than I was driving. You see, the main reason why I got my brother to come with us is because he is named after our grandpa in Pendleton. He was crying too, but we tried to talk about more pleasant things about past memories to make us laugh. We finally reach the canyon that over-looks Pendleton. My brother's wife asks me if I want to drive, but my brother says in a stern voice to keep on driving. My two bitty- ones were sleeping in the back buckled up. His wife asked me to drive because she was

not compatible with that part of the country. I think she did well.

We finally reach the hospital, and we drove right back to the emergency doors. We rushed right in there as my brother's wife went to park the rig. As I was going up the elevator I remembered how I was told that this was the first hospital I was in after the two- horses rolled on top of me. When we reached the third floor and stepped out of the elevator there was a waiting room we had to go through. We asked the people who worked at night where our grandpa's room was and right after I had asked I saw some of our family members crowding into a room.

We got in there and moved our way easily past them people and went right to his bed. I could see my grandpa fighting for air, and I saw him hooked up to a machine that had a whole bunch of wires attached to it. Our grandpa is the father of our late mother. I right away gave my auntie a reassuring hug letting her know that we were finally there. Her eyes were sad from the heartache she had to endure since her dad started having these problems. She was sitting on the south side of the bed, and my uncle was sitting on the north side. He got up so my brother and I could be right beside the bed. My brother sang a sacred longhouse song. I sat there a few seconds before I started to sing a song I knew. It was my brother who sang the 3rd song. He says that three- songs have been offered, and then the night went on. My uncle's son was sitting in the corner. It was very early the next morning. There was a lot of family there. My cousin's wife was there also in the room. It was not long after we got there that my brother's wife came up the elevator with my children. I gathered up my children close to my grandfather's bed. They did not know how to feel as they looked at my grandfather struggling to take each breath. I told each of my children

to touch his hand. They did as they were told because they know how to treat an elder with respect, especially a veteran. My other cousin comes in the room who is the son of my auntie I described earlier. His eyes were all red from crying. I couldn't really see my uncle's eyes because he was leaning over on the bed next to our grandfather. The nurses came back to the room once in a while to check our grandpa's IV.

My children were getting tired, and we have an uncle over there that stays in a housing complex where they asked me if they could take my children to get something to eat. I had that feeling that I needed to stay at the hospital. I let my children go because they were with family from over there in Pendleton, and I knew that they would be taken care of. I saw my grandma from over in the valley; she was with her son who drove her. She is the sister of the one who was lying in the hospital bed. She would always give me a check- up on how he was doing because she always had contact with them.

Our grandpa is a pow-wow dancer known all over because he is a World War 11 Veteran, and a traditional dancer on the pow-wow trail. It was my uncle who drove him to pow-wows after he got too old to drive. At the Pendleton Round- Up every mid- September he would always be dressed up on his white horse. He looked so magnificent. But, time goes by so fast in a slow kind of way.

I was kind of tired because we had to leave the Yakama reservation in a hurry. There were some family members who stayed in his room as my auntie and I went out in the waiting room to catch a bit of sleep before the sun rose.

When I woke up in the waiting room a few hours later my auntie had already got up and went back to her dad's room. I had coffee in the waiting room before I headed back to the room. I was wondering how my children were doing as I walked down the hallway to the room. I saw my grandma sitting by the bed of her brother who was still gasping for air. I was the main one who would get my auntie around because she had no car. So, I took my auntie and cousin home so we could get cleaned up. We knew that there was always going to be someone there with our grandpa. My uncle who was closest to our grandfather because he drove him to pow-wows introduced us grandchildren to an uncle that we never met before who stays in Pendleton. It was nice to meet another family member.

I decided not to take a shower that day. My family took one right after the other. We had a good day as time just went by slowly. We were going to head back to the hospital, but before we went back there I decided to take the Bitty ones some clothes and something to snack on. They were happy to see me even though they were watching a movie. I gave them their belongings before we headed out.

We got back to the hospital to see our grandfather in the same condition. I had learned that our grandfather's lungs had just about collapsed. I called my children's school to tell them where we were, and got them excused. I also called up my friend in the Valley and told her what was going on. I felt kind of dismayed because she was worried of the kids missing too much school. I told her of my grandfather's condition, and she told me that something like that can go on for days' What I didn't tell her is that it is a condition that started in our grandfather a year ago.

There was still some deer meat in the rig saved from our journey over there, and I passed it out at the hospital. My uncle we were introduced to went to the store and bought us some more to snack on. Nighttime was coming again. My auntie wanted to go home to get some rest because she was again tired. Her son came with us again. We left the hospital with our uncle there, and his daughter-in-law. I was tired too. When we got to my auntie's house it was a new house that she just moved into a few weeks previously. She had stuff out in her garage she had to unpack yet. My cousin let me sleep in his son's room on the floor; I mean on a small mattress on the floor. Well, before we went to bed my brother and his wife created a good meal out of the commodities they had, and a little meat. My brother is a well- known cook of the Valley. It was a very good meal.

The next morning I got up early because I had a good night's rest. I didn't hear anyone getting around, so I headed for the bathroom to take a shower. Not until I got out did family members start getting around. I was running out of power on my cell- phone. My auntie tells me that I can pick up another battery downtown. That makes me feel better as my auntie tells me that she has business to do over at the clinic with my sister-in-law. Her son joins them in the walk over there.

I had that feeling I needed to be at the hospital, but I knew better than to rush my auntie while she was doing something. I waited for a bit before I headed for the rig to warm it up. It was really cold in that part of the country late November. As I was going to head back in the house to warm up, my uncle calls me from the hospital as I enter the garage. He says real low, "Grandpa left at 8:29 this morning."

His voice was not shaky, it sounded calm; a moment

he had to wait for. He said that briefly before he hung up. My cousin was walking ahead of my auntie. When he reached the porch I broke the news to him. I could see him hiding his pain to be strong for his mom. When she got back to the house I told her the news. She did not cry as we hurried up to get down to the hospital. I had to make sure that my kids were all right.

When we got to the hospital there were a lot of family members there. My auntie went right to where our grandfather was lying in the hospital bed. My grandmother was crying uncontrollably. When my brother entered the room, he wept because the person he was named after was lying in the bed without breath coming out of his mouth. I wanted to cry, but I have learned in attending dressings that a person is not supposed to cry for the one who left until that person is in the ground. My auntie and the family who were closest to him wept, and I just gave them reassuring hugs being strong.

The family was deciding what to do. There were a lot of arrangements that had to be done. My uncle decided after co-in siding with other family members to have the dressing at Burns Mortuary. The main family was going to meet at the mortuary to decide what was going to be done about the body. My auntie had to be back at her dad's house, but she had some stuff she had to do in town first. While she was doing that I went to US Cellular right by Wal-Mart to exchange my battery. It was not too long before the family was going to meet.

I've never been to a mortuary before where they were going to decide on the services for one that passed on. There was quite a bit of family members there who gathered in a room that was sort of small. When the mortician figured that all the family members were there he shut the door. Our older sister found out that we were

over in Pendleton, and she wanted to be over there right away because she was feeling our family's pain. Our uncle was the one to go over to the Valley to pick her up. The room was dark with more family members pouring in. It was amazing for me to see my brother, sister and me in the same room together. It was our uncle from over there in Pendleton who was going to be in charge of the services. He had said that after a person has left this world, that the body can only stay above ground for three- days. At his house it had to be cleaned for after the dressing, the body was supposed to go back to the house for the last time a couple of hours. After the body was to be at the house, he would be taken to the longhouse there in Mission for services. The burial was to be at the cemetery above the longhouse.

There was a bit of stuff that had to be done. When we got out to his house in Mission, all the pictures had to be removed from the house and put away for a year. His body was going to lie in the living room for the last time. I helped take down some of the pictures and placed them in his old room. Right after I got done doing that there was a pile of dishes in the kitchen. Me, being me I started to do them. My cousin comes in the kitchen and says that dishes don't need to be done because they're all going to be given away. I told him that if they are going to be given away, they are going to be clean. His house really needed to be cleaned.

I went to see my children again, and gave them another pair of clothes. I just kept the dirty clothes in the back of the rig so I can wash them when we get home. The main family members had a dressing to be at one o' clock. The children are part of the family too, but their too young to be at a dressing or funeral.

I had forgotten to bring my wingdress because we

had left the Valley in such a hurry. My auntie had some extra dresses that my sister and I could wear. My auntie and I braided our hair. Her son, her, my brother, his wife, sister and me all crowded into my van. When we got to Burns Mortuary there were a lot of people. Auntie let me use one of her shawls she had put away. I put on the shawl right when I got off the rig because I knew that the women must wear it. My brother had to wear a ribbon shirt just like all the other men. At the beginning of the ceremony the men had to be on one side, and the women on the other. The person who left, his children and other real close relatives had to be standing in front of the people. We had to be with our auntie and uncle because our mom was their sister. My brother has his name to carry on.

As the body was bought into the room by the two-respected Veterans, I realized something; I had never in my life been to a dressing where the body was dressed right before my eyes. It was a very touching moment for me to see the Veterans move his arms and legs to dress him, but I knew that I had to be strong viewing the movement of the body. I could hear the weeping of women. When it finally got to be our turn to view the body, I couldn't help but let one tear escape my eye as I looked at my grandpa lying in the coffin so peaceful. I raised my arm and turned around knowing that he was no longer in pain. Viewing the body was hard for our auntie because she shared so many loving moments with him in his life. It was hard for our uncle because he shared in his life also, and drove him to pow-wows. It was hard for the whole family to see the coffin close holding our grandfather.

The body was to be taken out to the house that was his for his final time to be at that house. When the body got there the whole living room area was clean. Outside

in the corral was his white horse; he was blind in both eyes. All the animals seemed to know what was going on because they were all silent as the cars pulled in. The coffin was placed right in the center of the living room. There were as many drummers as there could be packed into a small space on the west side of his coffin. The men were on the north side, and the women on the south side. There were a lot of both genders in the house. When the drummers started to sing the final seven that would be done in his house for him, I danced on the side as hard as I could because I knew that my grandfather would have wanted it that way; he danced all the way to the end.

The service was over in his house and his body was to be taken to the longhouse for the last time. When we got there we had a little time to be away from the body until night services would begin. My auntie wanted to make sure that the gravediggers had been notified on where to put the body. They followed us up to the Agency Cemetery where our mom is buried, and the other members of our family. Our auntie showed me the grave of our mother. The only thing I can remember about her death was the dressing. My brother and sister cried because they knew her better than I did. All I could do was view the body and tell myself, "This was the woman who brought me into the world." I didn't have any sentimental feelings for her. I just went and stood by my grandmother again. My mother had died a few months before I had gotten in the horse- riding- accident. When we got back to the longhouse it was mealtime before the services begin. It was a good meal to nourish the body before the dancing was to start. I danced as hard as I could again letting the sweat just pour down my face. I was dancing in my socks because I had no moccasins. The coffin was covered with an American Flag, and it had a tulie mat to sit above on. There were quite a bit of people there too. Our uncle also had members from AIM to sing a farewell

song as well; it was very beautiful. After services were over we went back to my auntie's house for a few hours sleep because the burial was at sunrise.

I woke up early the next morning as the rest of the family members did. We got to the longhouse to do the final seven before the body leaves the longhouse to go up to the burial site in Agency Cemetery. The final seven was done for the body before it left the longhouse for the last time. My daughter and I are usually flower girls at these sorts of processions, but we had to be one of the ones behind the body because he was a close family member. I still could not have my children with me even though I missed not having them there, but I felt they needed to stay at our uncles until after the crying ceremony. When we got up to the cemetery we had noticed that the gravediggers had dug the grave. There were a lot of people at his funeral; he was a much respected Veteran. A ceremony was done for him by the Warriors Association from over here at the Valley. Then, there was a ceremony done by another group of men who serve in the armed forces. At the end of the service the two- men doing the ceremony folded the flag that covered the coffin in a symmetrical triangle, and gave it to my auntie. I did my best to be as strong as I could by singing loudly, and looking up at the sky. I knew that there was a ceremony for tears. My brother and sister also visited our mom's grave before we left the cemetery. We all made our journey back to the longhouse.

At the longhouse I decided to check the messages on my phone, and I had a message from our auntie over in the Valley. She wanted to attend the funeral because she wanted to take our sisters children over there that she has custody of; he was their grandfather too. I had turned off my phone after the dressing because I thought that no one would give me a call; and I didn't turn it

on until after the burial. When we got there, the main family members had to come in from the eastern side of the longhouse. It was the men who had to go first, followed by the women. It was our uncles who had to go first followed by our brother, and cousins. Leading the women was the sister of the departed one who was real torn apart. They were followed by our auntie and the other women according to age. When we got to where we were supposed to be seated, it was time for the crying ceremony. The belongings of the departed one had been bought out onto the floor. There were a lot of tears by both the men and women. Clothes that I can remember seeing on the smiling face of our grandfather were no longer to be worn. The regalia I can remember seeing him in at pow- wows, and the cane I can still see him using, were to be used no more. As these items were taken around the longhouse tears streamed down my face because now was the time to cry. No one that close to me that I have known has died before my eyes. It was a very touching moment for the whole family.

After the crying ceremony had been done, there was going to be a meal. Before the meal was served by the women who had agreed to cook for all the services, I knew that there would be a little break. I really missed my children and went to go and pick them up. They were very happy to see me as they happily got in the rig. They told me that they were very hungry, and I told them they are going to have a meal at the longhouse. It was a very good meal to fill our bodies up after it had been through a lot of mourning. We shared in joyful moments to help keep everyone in a happy mood. After the meal it was time to clean up the main room so we can get on with the final ceremony; the giveaway. I felt a little awkward because I was helping clean up, but I also felt that I had to because that is a womens job.

Well, when the services were still being arranged my uncle and auntie had said that all his clothes would be burned, plus the furniture he used. But, there was a woman who is very traditional say that all the belongings had to be given away. All his stuff had been placed in the southwest side of the longhouse. All the dishes, pots and pans had to be given away also. All the main family members got an item that was his. My son got a pair of moccasins, and my daughter got a nice gift also. When everyone was called out to the floor to get the rest of the items, I went through them and got some kitchen belongings. My daughter had gotten a little bag. She right away came up to me and showed me the items; they were his medals. I right away went up and showed them to our auntie. She then showed them to the leader of the longhouse who gave out the medals to Veterans. When the floor had been cleared it was time to do the final song. I sang as loud as I could.

It was finally time to be heading back home because my children had to be in school the next day. My brother and sister had decided to stay over there with our uncle. We packed up the stuff we had received in the giveaway and headed out of there. Well, before we headed out we gave our auntie and cousin a hug. They don't have to hear it from us vocally, but they know they will always be in our prayers. When I talked to our uncle and asked him what I should do for my children because they both have pow-wow titles to hold on to. He tells me before we left he had talked to a very important leader in Pendleton, and he said that the main mourning was for the main family members; the sons and daughter. So, I gave him a hug.

The reason why I had to do this writing is because this is the best way for me to express myself. It had a big effect on my life, and I cried some while I was writing it because it still hurts me. Our grandfather had left this

world on November 29th, 2009. It has been my first time I had been with a body since it was alive, and to the time when he was put underground. I had to tell you every detail because that is how I am. After we had gotten back to the Valley it was kind of a rough situation to be in, so I thought. I had the kids back in school, I was doing okay. I went to the agency to walk around a bit because I kind of felt in a daze. When I looked up at the bulletin board in front of the agency a flier of him dying was still hanging on the wall. I fell apart seeing his name again. I walked out of the agency back to the rig. I was still hurt. I'm amazed that I could drive hidden behind tears as I knew that the safest place for me to be was at home. At the New Years pow-wow I had all of us released for my children's' sake, and mine so I can go and gather the food and dance at pow-wows. We were released by our uncle who is a much respected man in the Valley.

CHAPTER 36

SHERMAN

I have been planning for a couple of months to see Sherman at the Whitman College in Walla Walla. I have been looking at his calendar dates on when he will read his poetry on the internet. He is so special to me because it seems like the dad he had and writes about, is the dad that I have. All the pain and misery our dad put us three-children through can never be healed. What he did to us as young children made us into the people we are today. When I am feeling hurt or pain, I don't know where else to turn except the pencil so I could take my rage out on it. When I read Sherman's poem, "When Asked What I Think about an Indian Reservation, I Remember the Deer Story", it spoke to my heart. The poem is in his book called "Face." I had to read the poem a few times to really catch the full effect. When I did I just started to cry. After I read that poem, I really wanted to meet Sherman. I just had to tell him what I thought of the poem.

Sure, he stays right down the road in Seattle, but he is so hard to come in contact with because he is so famous. And, to tell you the truth, I never been to Walla Walla before. When the week was coming up for us to meet him my friends got to saying that I should not go because of

my children. Sherman really speaks his mind, not afraid to use bad language. I just couldn't leave my children behind because we do almost everything together. I tell those people that my kids hear bad language at school from their friends. So, my mind was made up. I felt this was the only chance for me to meet him.

After the kids got out of school on the 15th of April we began our journey over to Walla Walla. From what I heard is that it will take about two- and- a- half hours to get there. My kids usually fall asleep whenever we go on journeys like that, but they actually stayed awake the whole time. When we got to Walla Walla two hours later I decided to take the kids to get something to eat. We couldn't stay long because Sherman was about to read in one hour because his show was at seven at night. I ordered our pizza to go as we got directions to the Whitman College. We drove around that campus two-times before we could find a place to park. The closest we could park was 3 blocks away. It was fun walking on a campus again because it reminded us of Bismarck. The kids were having a good time playing on the benches used for students to sit on.

When we got to the Cordineer Hall and went in the doors I saw the man selling books and realized I forgot my purse. I had my kids run back to the van to get it because I definitely wanted some books of his. As they went out to the van I went into the room where he was supposed to speak. That whole room was filled up as a lady on the microphone was introducing Sherman. After a while my children come back with my purse. I kept on impatiently waiting for Sherman to come onto stage. What I didn't know is that he was sitting in the front row. He was finally called up onto the stage. There were a lot of cheers, but I made sure that mine was the loudest. He was real good, and I will admit, his language was kind of mean

spirited; but he got out his feelings the way he knew how. He was a comedian the most of the night because he spoke at the Whitman College classes earlier that day; so the audience seemed familiar. The show went on for about 1 and ½ hours. He was about to bring up question and answer time. As he did there were about 10 students getting ready to head out of the room from the first few rows. Sherman says that it is question and answer time, but he says, "Oh, we'll just skip that part so I can go and sign autographs." You see, it was near the end of the night and Sherman read his last poem earlier. I called out from where I was standing, "Sherman". He looks around at the audience. I call his name again, "Sherman". He still couldn't find the one calling out his name. So, I say again, "Sherman". He looks right at me.

I got up closer to the stage. He can finally see me. I ask him about his father he wrote about in his poem "When asked About What I Think about an Indian Reservation, I Remember the Deer Story", I couldn't really hear his answer, but it was his father. He told the audience that he will read one more poem that night; he had that book "Face" right in front of him. He read the poem because I asked him about it with such force and meaning that it just made me cry. As he was coming off stage to where I was standing he hands me the poems he was reading that night and just gives me a full embrace as I went crying into his shoulder. I tell him while I was crying that he is my hero. When we got done hugging I knew that I had to thank him for reading that poem, that is our way. I had a 4- Directions medicine wheel on my neck made by my good friend Ted Williams that I really cherish because it is the emblem to the best college I have been to in Bismarck, North Dakota. I took it off my neck, and placed it on his. It was time for autograph signing of his books out in the lobby. There was a great big line, and we made sure that we were the last ones. As our time

finally shows up it was about 10: 45 PM. I got four books of his; two for me, and two for my daughter because she likes to read his books too. He signed both of them, and specifically the two poems I asked him about, he wrote, "A Special Friend". Then, he wrote his signature. I then gave him the book I have been working on since 1997. I also gave him my business card so he can contact me. He told me personally that he will read it, and keep in contact with me. He really loves my children. While he was signing autographs my son Scwe'lelut was leaning right next to Sherman and he asks him, "When are you going to stop writing?" Sherman had to chuckle at the question. He leans over to Scwe'lelut's head and tells him, "Probably until I'm dead. I'll be writing, I'm dying, I'm dying, I'm dying, I'm............" Then my son just broke out in laughter. I got a picture with him, then, all of us got a picture together. What I didn't see my son do was put bunny ears on Sherman because he made such a good friend. My daughter Riata was the first one in line to get his autograph. As we were leaving Cordineer Hall and start going down the stairs Sherman was leaving to go to his car. We all wave at him, with him waving back. I will never, ever forget the time I met my hero.

CHAPTER 37

TWILIGHT

I want to say what the movie "Twilight" means to me: Back in 2004 I was with this guy who is a Marine Veteran. I didn't think he would possibly be interested in a person like me. I was attending United Tribes Technical College in Bismarck, North Dakota in the years of 2003-05. I was having problems at the end of winter there; the winters there can be pretty harsh. Instead of taking my van I owned at the time to a mechanic in town, my friend who went to Tribes in the major of Automotive Technology said I should take my van there. It was about 10 in the morning. I already had my daughter off at school on campus, and my son was taken to daycare on campus too. I didn't have class until eleven that morning and I took my vehicle to the building I was asked to go to. When I got to the garage I saw students working on cars and trucks. The head- mechanic comes up and talks to me asking me what they can do for me? I kept on wondering why my car would only start up sometimes, and they found out; I needed a new battery. While they were looking at my car I started in on talking to this guy; he was a very handsome young- buck. He ordered a battery from the dealership in town that Tribes goes to for the inventory. He told me I can come back later if I have class to get to. I tell him that

I will just wait because I'm sure that my instructor knew the importance of having a rig in them parts. I just kept on talking to him, and talking to him because I knew that he would be a good friend, for I never expected to get a boyfriend, especially with my disability. He acted like I was any other person, and treated me just the same. After a couple of hours my battery had arrived. The head mechanic could see that we had a little fancy for each other, and he let the one who I've been checking out put in my battery. I didn't want to leave, but I figured that I should try to hold down some lunch with my heart just yearning hoping that I have found that certain someone. He gave me his phone number to his cell, and all I had to give him was my home phone number. I will tell you the truth, I didn't really think that he would call because I looked at myself as a small rez' girl. He was such a fine dresser who always had nice clothes, and had a nice butt. He had short hair, and looked kind of mysterious; I will say that's what attracted me to him. I was amazed he gave me a call the next morning and asked if we could go for lunch that afternoon, and I happily agreed. I went to class that morning with a smile on my face because it feels like something is going to happen. Anyway, we had a good lunch. He invites me out to a bar that night. I am not really too comfortable in bars, but I wanted to spend as much time as I could with him. I had the lady who stays next door to me on campus watch my kids because my children liked to play with her children. I absolutely loved to be with him. I took with me a non-fiction writing that I wanted to share with him. He takes me to a corner in the bar where he can hear me talk. He kept on watching me as I read every word; it's like he was captivated. When I finished he was so amazed that I could be so open about myself because he was raised almost the same way I was; with the same kind of abuse. He was sitting across the table from me at first. When we really got into talking he sat right by my side. We begin

to play with each other's feet. It was hard to take my eyes off him because he is so handsome. We danced for a bit to calm our nerves down. As we were sitting at a table side by side as time flew by, he puts his face by my face. He extends his lips in an outward pucker and gently pecks my cheek. EEEEWWW!!! It felt like my emotions had wings that were just fluttering with happiness! He pulled away a little thinking he had done something wrong. I let him know that I want him to stay close by pecking him on the cheek. After a while of us playing with the others face with our tongues we didn't care who was watching us after that because we were madly kissing, and holding each other in an embrace that would make lovers crazy. After we were done kissing we did not want to leave one another. We just talked about how I was raised, and he told me a little bit about himself. We ended the night going to his apartment. As we got there I felt so lucky for him to be a real gentleman and open my car door for me; he had a little car. I walked a little bit slower because of my bad leg. His room was part of an apartment complex; it was on the 2nd floor. I had a little bit difficulty climbing the stairs, but I stayed by his side; he has such a fast pace when it comes to walking. It was a very old building, and his room had a bed right in the middle of the room right before the kitchen, and a little bathroom. I sat at a table, and he sat on the bed; we just talked about what I read to him in the bar. I could tell he was holding something back from me, but it was his place to where I did not want to push it too far. He had a drink he made called a ½ and ½. But, we ended the night on the bed lying side by side. He told me that some of the bad things his family has done, and how much he wanted to receive his degree in Automotive Technology. I spent the whole night with him falling asleep in his arms. The next morning came much too quickly as it was really cold outside; we got up around five in the morning. What also really amazed me was that, he didn't even try to make any unwelcome

advances. I left that morning with a goodbye kiss back to Tribes campus. It was Spring break, and I drove my children back to Washington State because I couldn't trust anyone enough yet in town because I was going to AIHEC for a week in Billings, Montana. It only took a few days to drive over there, and back. When I got back to campus I had like a day to wait, so I went to his apartment. After a while of being together that beginning of Spring break, where do you think we got. Anyway, after a night of passionate love he tells me as he was holding me in an embrace that he loves to watch me sleep because I look so peaceful. He asks me if I really like being with him because he is very risky? I tell him that is alright, I liked being with him because of all the guys I have been with, he is the one who has been the most gentleman like, and treat me like a lady; a way I felt I have never been treated before. As I was getting ready to get on the bus to head for Billings, I did not want to leave his loving arms, but he made the separation easier by giving me a goodbye kiss that will last all the way through AIHEC. Oh, Billings was great place. There were a lot of good- looking long haired Natives from all over the United States, but that kiss I got from my honey back in Bismarck was able to keep me from the messing around stage I could have done. I had a very good week over there; I entered the Non-Fiction department, and some of my artwork. As we were heading home I kept thinking to myself, "Maybe he found someone else because he is so good looking. Maybe he forgot about me." But, as we pulled into Tribes, he was waiting there where the bus stopped to let people off, and gives me a good long kiss to welcome me back. I spend another fantastic night with him as my insides were just goin' crazy. I went back to Washington to pick up my kids at my aunties house before I started back up in school. I tried as much as I could to see him, but it finally came to that time where he broke it off with me because he knew that my schoolwork was not that well because

of him. It was very hard for me to tell him goodbye, but it was for the better. I will say, that was the best spring break of 2004 I will never forget. A few months before I graduated I got with this other guy who was a Heyoka, a very tricky kind of guy, but I liked that. He asked me if I was scared of him because most women are. I like living on the dangerous side, so I told him that him being that way don't scare me.

Anyway, about how I like the "Twilight Episodes" so much is how Edward says to Bella that he has been waiting a long time for someone like her; how the lion fell in love with the lamb. After all I have been through, I am like the lion, and whoever I fall in love with is like the lamb because I have to basically break him in on all I've been through. I also like the part when Edward tells Bella that he likes the way she sleeps because it is so fascinating to him; this man I am talking about who treated me like a real lady told me one morning that he likes the way I sleep because I look so peaceful. All the abuse that he went through made him afraid of his own shadow; really cautious and wary. He is also a Veteran who had to witness death. I haven't found anyone to love in the longest time because I feel their scared of me. I am not afraid of living on the risky side because that is how my life is, and I have been with some real crazy guys that would drive a not- normal person crazy in the head. I was with this man after I left my true love of spring break, and not long before I graduated from Tribes who began to beat me terribly after a few months of us being together, and the only reason I left him was because my children had to witness most of the abuse I went through. He made me end up in a place for Battered Women who have suffered abuse in Bismarck. I still remembered what he said as he tried to convince me to stay with him, "You are not going to have another man in your life"; and that is still holding true to this day. He beat me up so badly

that at night I would have nightmares fighting my pillows. I cried to the counselor who was helping me recover, and she told me that most of the women who are in that shelter are put through the same thing. I wrote a poem while I was in that shelter because I felt I had to, it was about the man who beat me. I showed this one woman when we were released from the shelter to go and live in town, and she wondered how I got the man who abused me into that poem because it sounded exactly like him. I even tried to make that saying not true by getting with someone not long after we came back to the Yakama rez' in 2006, but it never worked out with him because he favored my son, over my daughter. I had that poem I wrote back in Bismarck published in the Yakama Nation Review because I know there are women out there going through abuse, and too afraid to admit it. Hey, I got my rope ready to catch that wild stallion, but I keep pulling in horses that are not strong enough to carry their own weight; I have to let them go.

CHAPTER 38

HIGH'S NEVER END

I have started up my own exercise in the year of 2009 in February at the Yakama Nation RV Park. I need to have an exercise because I need to get the muscles working on my right side again because I had a whole right- side paralysis back in the end of 1992. Anyway, I have to do things that really challenge me because I never believe in the "easy way" out. I can't run because I had a limp. I began to dance; not just any kind of dance; traditional dance. I do that because it works out every muscle in the body. I have met a lot of great people through doing something like that because as I dance by their RV, I pick up their bad moods and make them feel better. Myself, I meet people mostly through my children.

In the summer of 2010 my son started to play with this Caucasian boy right by the drainage ditch at the RV Park. I would always go exercising at the park, and sometimes stop to visit with our good friend Joe, who we have known over a year. My daughter began to go with her brother over to his friend's trailer and got to know the boy's mother who had a TV in her trailer. After a day or so of my children going to visit her I had curiosity get the better half of me. I wandered over to her trailer and got

to know her, and her husband. Her name is Leanne, and her husband's name is Gerald.

The family of the "Highs" got to be our lifelong friends because they are nice, and do what they say they are going to do. All that summer of 2010 we went over to the RV Park whenever we could; mostly to do my dancing, or to visit. What else I also did at the RV park was that, I am in a sculpting class with the retired world famous taxidermist Mark Bahm. He told me that he started the class because of me. He has seen me doing my walking 6 inches apart each step. He has decided to make this class his last because he likes my spirit on never to give up. He stopped feeling sorry for himself, and he wants to help others. While I was at that class my children would go and visit with Leanne, or just play at the basketball courts.

At the time last early fall I was having a bit of a problem with the oil leaking out of the place we put oil in. It took a bit of money because both Gerald and Leanne used to take apart engines, and put them back together again. I was on foot for a while, but all I had to do was buy the part, and Gerald fixed it for me. I felt so relieved because it is so strenuous to be without my rig. I'm so glad they got it working.

It came to that time of year we hardly saw each as much as we would like. My son's friend Wyatt went back to stay with his father. School started again. The weather turned colder as the first snows came a bit earlier. Kind of cut down my time of exercising. I have shared with them and let them read the rough drafts I have of my book; they have told me they really liked it, and encouraged me to publish my book. I had them both behind me. I have found a cigarette in the van when I was cleaning it out. I was so mad because I knew that it was Riata. I

told her and her brother that smoking will only hurt their bodies. I didn't know what else to do. I have told my friend Leanne while her husband was sitting in his usual place at the table which had a light above it, and a laptop on it; of course there was an ashtray. Leanne was so mad, but took it out on a more forgiving way because she told the kids that she has a very hard time sometimes breathing because she used to smoke. And Gerald said that he has full blown bronchitis from smoking, both his lungs are ruined, and he asked the kids if they want to be the same way? I believe that was a real eye- opener for the kids because they have seen what they will turn out like. Our friends love my children, and do not want harm to come to them with the use of stuff that will hurt your body. I was real thankful when I left the trailer. Time moved on slowly, but also fast it seemed.

It was that time of year in at the beginning of March. I was having a good time dancing around the park. I was going to stop and visit with my friends, but I decided not because I had other stuff to do while the kids were in school. As night was coming I went to my son's elementary school because it was reading night for the family. My son was having a good time visiting, and playing games with his classmates.

I all of a sudden got a phone call from my good friend Leanne. I thought it was to ask us over for a visit or something like that. I was listening to a lady read a Dr. Suess book to children who wanted very much to hear it. When I got the call I went out into the hallway so it would be a bit quieter. My friend Leanne greets me, and asks me if I'm sitting down? I tell her no, but went over by the doorway so I could be in silence. She tells me very briefly not chopping it into pieces that her husband has passed away.

I couldn't be....How could he be gone? Why is Leanne being so honest and brief? He and his wife were like part of our family. She spoke of the services that were to be that following Saturday. After I clicked the end button on my cell phone, I sat on the floor with astonishment. My children could see that something was wrong by the way I was acting. They right away came over and knelt on the floor by me putting their arms around me. I told them who it was who called me, and told them that Gerald had died. The children were all quiet because they knew him.

I had other stuff to with my daughter during the week, and also that Saturday. But, he was our good friend, and I wanted to be there with the family because they are like our family. I had a sculpting class to be at that day, but my friend Mark knew him too, so he excused us for he knew where we were going to be.

I felt a little weird because usually at services for someone who has left this world, we would dress up in our regalia. But, this was a good friend who we met at the RV Park. He always knew me as a person who likes to exercise. So, my children and I dressed casually. Where they were going to have his services was in Zillah, just outside of Toppenish. We also felt out of place because it was a service for a white man. We didn't know what to do. We were told that my son's best friend Wyatt was going to be there. When we got in the place where it was supposed to be there were a lot of white people, some who had their children with them. There was some food prepared on the table which I didn't feel comfortable taking because what and who we were there for. My son was hungry because we barely ate breakfast and he grabbed himself some potato chips. I thought that was alright because my daughter got a plate from the counter and started to serve herself out. I did the same

because the food looked delicious. There was this lady there who asked me if I liked the macaroni salad, and I told her I liked it very much. She told me that she is the one who made it.

We went and found a table in the corner we could eat at. The place was little with a lot of people in there, but we seemed to fit alright. In the bar area there was a lot of people because that was where the minister was. I wanted to get back there, but I thought it might be disrespectful since I am not from the family. As we ate, my son got to visit and make more friends. There was this couple sitting at a table with their relative who I asked what we do at services like this? And, the husband tells me that we just must come to get to know the other people if we don't know them.

Scwe'lelut found his good friend from over the hills Wyatt, and they went over to the part of the room that had pictures of Wyatt's grandpa. I looked at them from behind the table I was sitting at watching them remember the good times they had with him.

Riata was sitting calmly across the table from me enjoying the food because it was good. I got to talking to this nice lady from Colorado who is the wife of a son of the departed one. She had a lovely child with her who instantly made friends with my children.

I wanted to see Leanne because I knew she was torn apart losing her husband that she was very close to. After a while she comes out of the bar room where there were a lot of people. She comes right up to my table and embraces me with the strength of her heart, and shoulders because she is a very strong woman both inside and out. She thanks my family for being there. We knew we should be there because I knew it would

be emotional support. She had a lot of people there to support her because her stability was hanging by the broken wings of a mighty eagle.

I have been talking to our friend Joe who stays at the trailer right next to them. He has known for some time. While I was at the park exercising he wanted so bad to tell me of the horrible news of our friend's death. What really hurts me is that, he told me that he was holding the head of the one who died; his best friend.

That really hurts me because I realize how strong of a person you have to be to let your good friend leave this world in your grasp. Joe told me that he never got to release himself because he had to be there to support his friend's wife who was quickly falling apart. When Leanne called and told me that Saturday night, it really hurt me. I couldn't go to the longhouse because I kept thinking of Joe, and how much courage he demonstrated. Well, we were going to go because Joe said he might go with us, but the next day he texts me and tells me that he has other plans. So, that day we went to Harrah Community church to be with our friends. I kept thinking on how strong Leanne and Joe had to be, and it hurt me because I don't know if I can be that strong. I was listening to the sermon Preached by their preacher. I let out prayers for Leanne and Joe because they are my good friends. My mind was kind of bewildered because doing what they did really hurt my heart emotionally. When the end of church was coming around I have heard the preacher mention a camp that goes on in the summer called "High Rock". It is a Christian church camp for one week out of the year that my daughter has gone to for the past two-years. I was feeling down and low until I got to thinking about what that camp is called, High Rock. High was the last name of the departed one and the name the wife proudly carries on because they had a beautiful

marriage being there for one another; loving each other in sickness and in health, pain or sorrow. I got to really thinking about camp, how it is called Camp High Rock. The one who left is now up in heaven looking down upon us. He is High up. Hearing those words lifted my heart to where a smile came out of nowhere and relieved my pain among the other church- goers. He is feeling no pain in this world no more because I have been in that place before. As of now, and forever more he is strong as a "High Rock".

I got to thinking about how Joe was taking all of this because he never really got to release himself, and I have told him that he must do that for his own good. Joe has said that he must get away for a while; away from everything, and everyone. He has told me that he has sort- of a job out on Marion Drain Road, but he is not very happy with it. He told me while we were visiting him that he wants to come over to our house and have dinner sometimes. I tell him that will be all right, but he never can make the time. When we try to come by to visit him, he is not home or away from his trailer. We try to visit with Leanne, but I know that she is going through a very rough time right now and we must not try to intrude for her sake. We are a very kind loving family.

I do hope and pray that they are getting the good help that they need because we love them like family. The last I heard from Joe is that the manager of the RV Park has raised the rent up to $450 dollars. Joe was saying that he was offered a job and he might go stay with a friend. He told me what Leanne has said about not being able to stay there because she won't be able to pay rent. I don't know what is going to happen to our friendship now. I can keep in contact with Leanne through the internet, and I have Joe's phone number. It will never be like it was used to, but what is

CHAPTER 39

INDEPENDENT MARK'S WORLD

You know, I can never get over the strength and independence of Mark. He moved with his trailer to the RV Park here in Toppenish a couple of summers ago. I met him at the beginning of the summer of 2009. It was that time of year when I made up my own type of exercise; I had my MP3 player at that time where I was listening to hand- drum played by "Red Tail". I would take a break here and there some days and walk. I have always been the independent kind of person and wanted to do things with a little bit of challenge in it; but there were days I was feeling low self- confidence in myself and just walked.

At the RV Park also there was a time for local artists to sell their work. My children and I set up my table to sell my artwork not too far away from the bathrooms. I had greeting cards and 8"x 10". There were a few people who came along who were walking on the track, but no one who would buy anything. There was a little trailer that was not too far from us. The man who is a white man wanders over to my stand with the wind slightly blowing. The sun was out that made shade on the hot day, but there was also a gust of wind that carried a bit of coldness in its breath. The man looked at my work and complimented

me on the exercising I did around the track. I told him about the incident I went through, and all the recovery I had to be doing.

He became my real good friend because I have shared a bit of my life with him; he told me his name is Mark. Every time we would go to the RV Park he would talk to me. During the summer it was very hot to make the sweat just roll down my body that was trying very hard to make my walk look decent because I had a very bad right- leg limp. People always looked at me weird because I was dancing, but that didn't bother me because I am a very determined person who was doing this for herself.

Mark noticed how I was walking around the track and how I was taking each step 6 inches apart. That made him a stronger person to have his last sculpting class. He was at first going to have that class for the handicapped people, but changed it after a month because people hardly showed up. He made the class for everyone. There were only five of us, but that was enough to get a class started.

I'll tell you a little bit about Mark's profession; he is a retired world famous taxidermist. He was raised around here, but he had worked on a couple of college campuses up in Alaska. He has been there for about 40 years, but wants to move back down here because he went to school in Granger, and his best friend was my grandpa. He has shown me a picture of his house in Alaska, and it is very beautifully set right next to a big lake with pine trees to overgrow it. He has shown me the ashes of the dog who saved his life

CHAPTER 40

SCABBYROBE TALKS

I was at the round dance last night, and I had the best time of my life because my children and I were waiting for the "Winter Round Dance" all year because we love to dance. The time in my life before we went to Bismarck, North Dakota and after I left Sante Fe, New Mexico and came back to the lower- Valley of Yakima for a death in the family, I was seriously in a downward spiral of self- pity. I got in bad relationships where two- children were able to come in my life and make me stop feeling sorry for myself because to them I am the strongest person in the world. Before my son was born, and while my daughter was real young I have been attending the round dance even when I had a bad disability that made it strenuous to walk. When we were little kids my grandma always took us grandchildren to the Community Center located in White Swan. We would have our regular every day clothes on, but we would practice dancing with the music by a drum called "WeaselTail". It would be just mostly some brothers drumming, and I think my brother went to drum with them a few times. I only knew the family that had the dancing practice was a family called "Scabbyrobe's". They were mostly kids about a few years older than me. The Scabbyrobe name came from Montana, and

is married into our family by my auntie Louise. My sister had a crush on a couple of the drummers, but I didn't because I was too young to even think about having a boyfriend. My grandma would always take us to practice every Tuesday, or Wednesday night of the week. As I got older when the Scabbyrobe group came out with their pow- wow tapes, I had learned that they had some good music. I loved to dance to it because it always had an up- beat. I always really liked how the lead singer Algin started out a song. The drum came up with a family name I called "BlackLodge". And, they also stayed a few or so miles down the road. I had my share of being different kinds of pow- wow royalty, and I would always get a good feeling inside when it was BlackLodges' turn to drum. I'll say, I believe it was their music I loved to fancy dance to because when they sing, its like time only moves to the drum. Over the years they have become a famous drum group that traveled all over the United States and Canada. I have always respected very much my uncle Kenny who is such a motivational speaker.

I have known the drum group all my life; it is like we grew up together, but grew up apart. Anyway, they stay not far from the LongHouse in White Swan. The sons have all got older just as I have. They have beautiful wives they have children with. I can respect that, but I always wanted to be great as them because they are my role models. I know they can't see the greatness in themselves because they go through problems just as anyone else.

Before we went to Bismarck, at the last Round Dance there was I listened to a speech by Kenny; I was really putting myself down because I was put through what my aunties were put through, beating both physically and mentally. I was also in a horse- riding accident that caused a blood clot to go in my brain, and the surgery done to remove it caused a whole right- side paralysis.

As I listened to my uncle speak, he said to never give up and quit dancing. I only briefly heard those words, but I was really wondering what he meant. I had a bad disability and almost wanted to give up so I can live under the care of others not caring where my life went. But, I still remember those words until this day. I have my own business going. I have both my wonderful children. I sell my artwork all over the United States. I have tripped and fallen down ridges many times in my life, but I always had the strength to get back up because I heard those words of encouragement.

At the last round dance that just got over March 11th and 12th 2011, it was the best one yet. All week we've been visiting with a church from the covenant college from Georgia. They came over to help our people in White Swan who about a little more than a month ago had to go through a fire that really shocked us here on the reservation because we never expected something like that to happen to us Native Americans at the foothills of the Cascades. The day after the fire there was no electricity in the town of White Swan, but the root feast was still held doing most of our cooking by the fire- pit used to cook salmon, and dry dear meat. It was such a beautiful day because I felt that needed to happen to bring us closer together and open our eyes. Anyway, this covenant college came to do some repairs to the damaged areas; which was a lot. The college did work for one week on a house, and also on the grounds where there will be a Sacred Road Church. And the following week there will be another church from Alabama and Mississippi.

We left to the round dance after we said our " See ya' laters" to the church group, and when we got to the round dance, there were already was a very packed parking lot of people who wanted to be there at the

Community Center in Toppenish. The round dance was too cool because my children and I have been looking forward to it all year; this year it was a little late than when it usually happens, but it happened. My children really loved the dance because they saw a lot of their good friends who were mainly their cousins because we are all related to each other one way or the other. It was very hard to find a place to sit down because it was so crowded. There were a lot of big name drummers from all over the United States and Canada. My son was so excited because he would get out there to drum; he didn't have his own drum because we left it home. My daughter would dance just like I would because she loves to sweat also. It was once in a while she went outside to cool down. My son fell asleep about eleven at night because he was so tired from the excitement of the night. It was time for the midnight meal as it rounded about twelve. It was only respectful to let the elders go first. I got to the end of the line I thought, but there was a whole big line after me. When I got up by my son I woke him up so he can get something to eat. My daughter was in line with her friends. It was a great meal that revived our bodies; I thought that eating would make my body tired, but it didn't. What we mainly did all night was dance; the round dance ended at a little before three. That was just the first night.

The second night after we got our rest was one of the best because my son decided he wanted to bring his hand- drum; which all the drummers share when they want to get out on the floor and drum. I will tell you something else too, there are two tables set up side- by side in the center of the room filled up with hand- drums for the drummers to grab. My son got out and drummed with the older drummers, and there were quite a bit little ones. It was very hot inside there as we all had sweat just pouring down our faces, and you could smell the perspiration

from all the other dancers. We danced rhythmically to the drum with each step magically moving our legs. My daughter was recording with my cell phone, and I got a little brave and asked one of the drummers to take a picture with me. He was out of breath since I asked him not too long after he stopped drumming before the next group came to drum but he happily agreed. I have admired him for a long time because I believe he does the grass dance the best. There was this other drummer there I admired for a long time to, but I asked him right after he got done drumming too, and he had to go outside and cool down for a while, and he said he will later.

As the night wore on to where it got ridiculously late my son finally after the mid nite meal went to sleep in front of the chairs. Just my daughter and I stayed up dancing. This round dance started about 12 years ago. I thought it was the drummers who started the dance up because they love to sing. But, what I found out this last weekend is that it is the Drug and Alcohol committee of the Tribe here on the Yakama rez' started it up to have a whole weekend drug and alcohol free. I was selling my greeting cards, and one person who is on the committee bought a pack. There was a time for the MC's; Kenny to award the committee for their work in bringing the people together. My friend who bought the cards from me, and I felt so honored that she bought my work. A wife of the longhouse leader bought a pack from me as well. I am thankful to the drug and alcohol committee for sponsoring such a great event for our people; I know a lot of people who are on the committee. It was a time for my kids and I to be together, we all had a good time.

My name is Say' yep um Ah-toot-wy Stacey Speedis. I am the youngest of three siblings who grew up on the Yakama Indian Reservation where we are enrolled members. In my life I have had many traumatic things happen to me that make me into the person I am today.

I have been able to come through these times with the help of Taman'wixla (Jesus) our creator. It feels like the LongHouse has been a second home to me because we have been brought up as food gatherers for our people. We also go to Bible Study every Tuesday night possible, besides going to the LongHouse. I want my children to know the creator because it feels like I had to piece together who our maker is all my life. Taman'wixla has his hands open, we just have to be willing to grab them so he can lead us through the difficult times in our lives. I am

a thirty- five year young Native woman who is not willing to give up on life. I have made up my own exercise at the RV Park in where I dance around the park because I cannot run. I have made up the dance February of 2009; I started it by listening to Red- Tail on my Mp3 player. My children and I love to dance because it is good for your heart. I love to travel and meet new people. I was raised around horses. My Ula'(grandma) would take me back to her room past suitcases and trunks to tell me some of our Native language. Her room was very packed with blankets and shawls and clothes, plus her other nik- naks.

My grandmother was fluent in our language, but I am still learning. I love everyone out there who believes in me, and I will do my best to make a trail for my children to follow. I love my family here on the Yakama reservation, and also the Umatilla reservation because I am ½ from my late mother's side of the family; even though they were not there in the toughest times in my life. I would like to thank my children for being there when I needed advice on my artwork, and for just being there. It seems like all the things that went on in my life were not easy, but what is? I know that I will have many, many more obstacles to get over in my lifetime, but I have to wait until that time gets here.

Thank you,
Say' yep um
Ah-toot-wy
Stacet
Speedis
SASS
'10

My name is Say'yepum Ah-toot-wy Stacey Speedis. The writing and artwork in this book are under the sole ownership of me, unless otherwise noted by me. . If there is any part of this book that you would like to include in your own writing, you will have to request permission from me.

Thank you,
SASSpeedis
'10